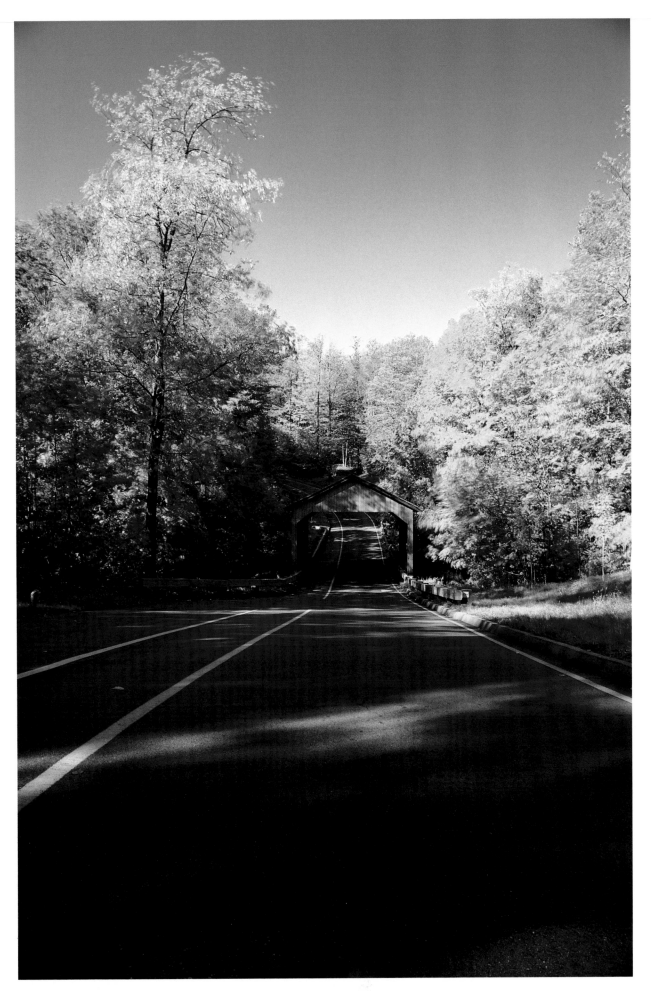

Bridge on Pierce Stocking Drive

Copyright © Terry Phipps 2004
All rights reserved
Published in the United States of America by
The University of Michigan Press
and
The Petoskey Publishing Company

Manufactured in Canada by Friesens
2006 2005 2004 5 4 3 2 1
ISBN 0-472-11445-X
Library of Congress Cataloging-in-Publication Data on File

Signed Limited Edition Prints
http://www.webspawner.com/users/islandimage/index.html
http://www.asmpmichigan.org/Phipps.htm
phipps@gtii.com

Seasons of
SLEEPING BEAR

PHOTOGRAPHY BY TERRY W. PHIPPS

The University of Michigan Press
Ann Arbor
and
The Petoskey Publishing Company
Traverse City

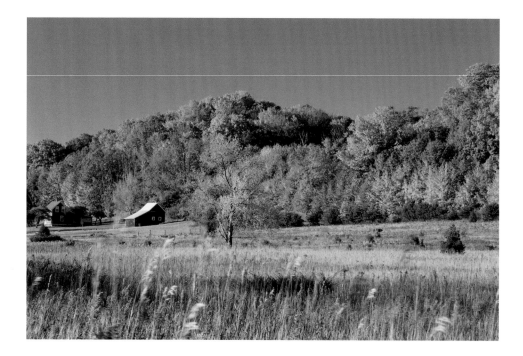

For
Becky Jo Hemmingsen

FOREWORD

Gracing the shoreline along the northwest section of Michigan's Lower Peninsula, Sleeping Bear Dunes National Lakeshore stands guard over the Lake Michigan's relentless eroding onslaught. Known for its rolling glacial moraines, its pristine desolate beaches and its towering sand dunes, Sleeping Bear holds secrets reserved for those who would explore the swales, back reaches and deep valleys not far off the tourist tramplings.

More culturally than historically, a legend once told by the Ottawas about the creation of Sleeping Bear lends poetic beauty to the landscape. As legend goes, a wild fire broke out in the far off Wisconsin lands; a mother bear and her two cubs fled with her two young cubs to the lake's safety. As the fire raged, the three swam Lake Michigan's width escaping to Michigan's safe shores. Before the family could reach the Michigan shore, the two cubs drowned and formed what we now call the Manitou Islands. The mother, who had made the long journey alive, lay on the beach and waited for her two cubs to return to her. As the days and months slipped into years, sand blew over the sleeping bear's body forming a sand dune now named Sleeping Bear.

Although Sleeping Bear Dunes National Lakeshore exudes history and culture around every cove, it wasn't established as a national lakeshore until 1970 when Congress passed the authorizing legislation. Initially, the bill that authorized the Lakeshore protected only thirty-five miles of Michigan's eastern shoreline. The total package encompassed 56,993 federal and 14,194 non-federal acres of forest, farmlands, beaches, rolling moraines, hidden lakes and undulating topography.

Sleeping Bear National Lakeshore has abundant attractions to offer including a broad historical farm district, three former Life-Saving Service/Coast Guard Stations, two lighthouses, numerous hiking trails and perhaps the best collection of coved remote beaches anywhere in the world. The Pierce Stocking Drive is by far the best way to see Lake Michigan from top of the dune elevations. The scenic winding road crosses a covered bridge to multiple vistas and picnic areas. From the Lake Michigan overlook, a ridge hike along the looming escarpment leads to a blowout, a crater-shaped dune with a lunar landscape. Within the bowl, a defoliated barkless, sun bleached cedar grove which some call the Ghost Forest, presents a stark contrast to the emerald water stretching into the horizon. Other notable areas certainly include the Pyramid Point, Alligator Hill and Miller Hill Trails. A favorite is Good Harbor Bay. A broad beach stretching from Pyramid Point to Whaleback can be accessed primarily at two points and along a roadway running parallel to the shoreline all the way to Pyramid Point's base. Sunset walks past the summer crowds provide wave-lapping serenity, and the haunting calls from off-season loons scanning silent shores amplifies solitude.

Come and experience the beauty, history and exhilaration Sleeping Bear has to offer; leave only foot prints and take only memories.

Makena Elizabeth Phipps

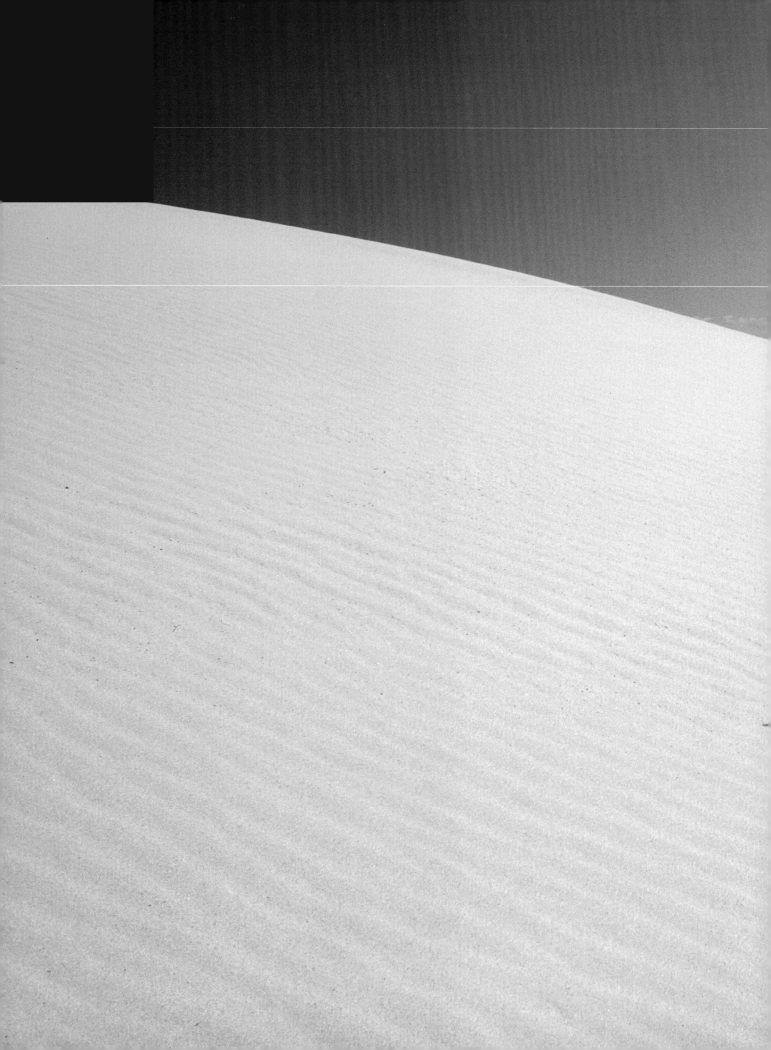

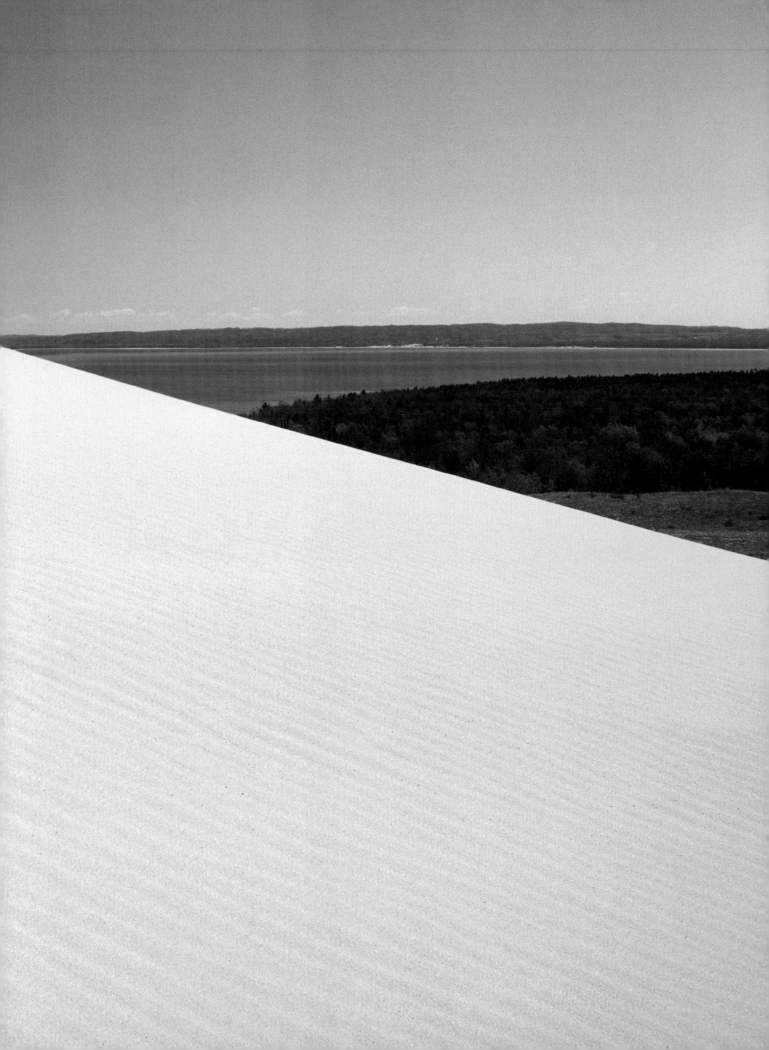

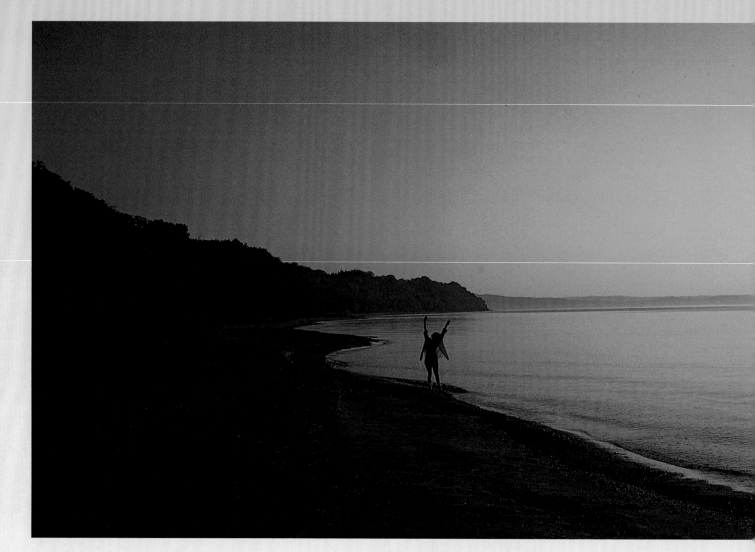

Port Oneida Beach

Previous page:
Lone dune at Pyramid Point

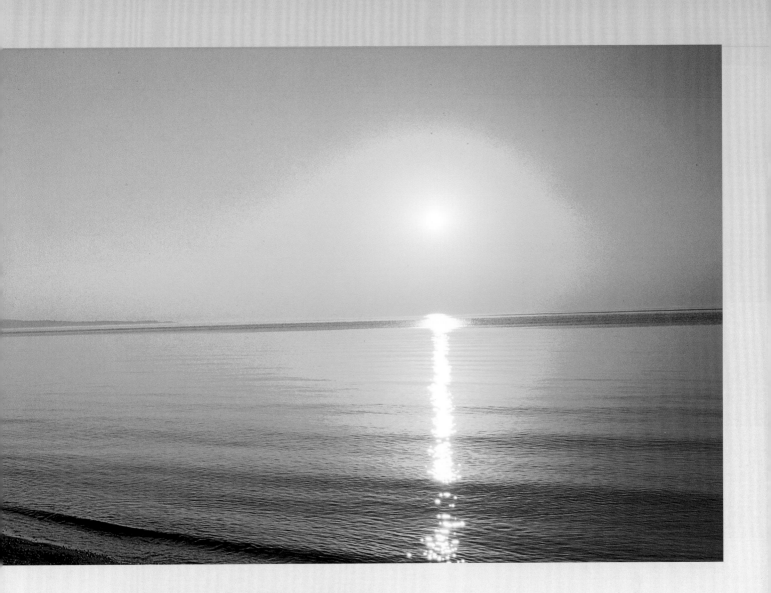

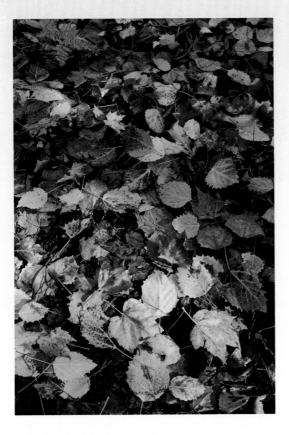

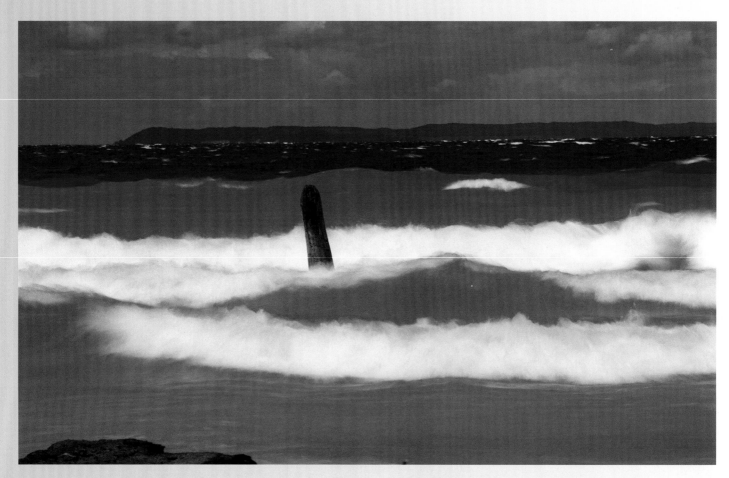

Good Harbor Bay Beach

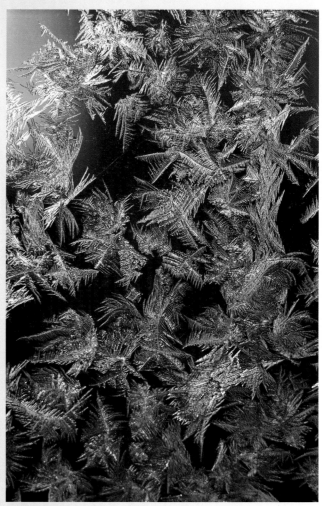

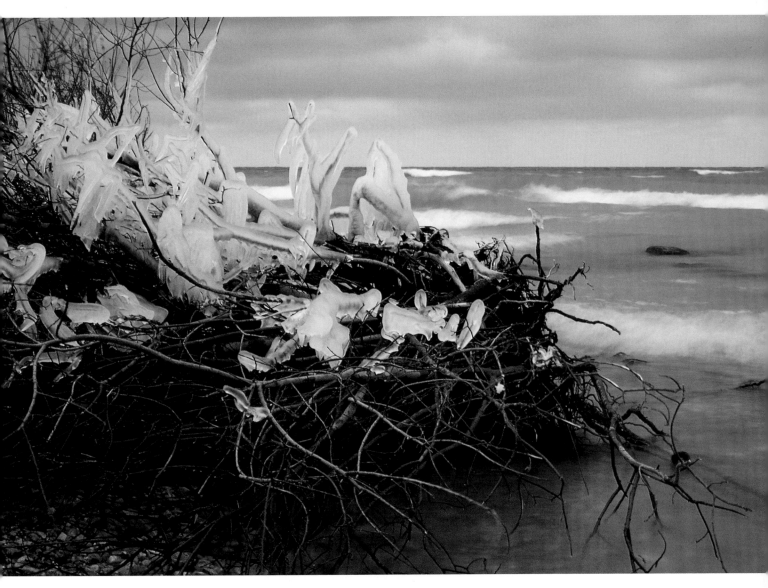

Iced willow at Good Harbor Bay

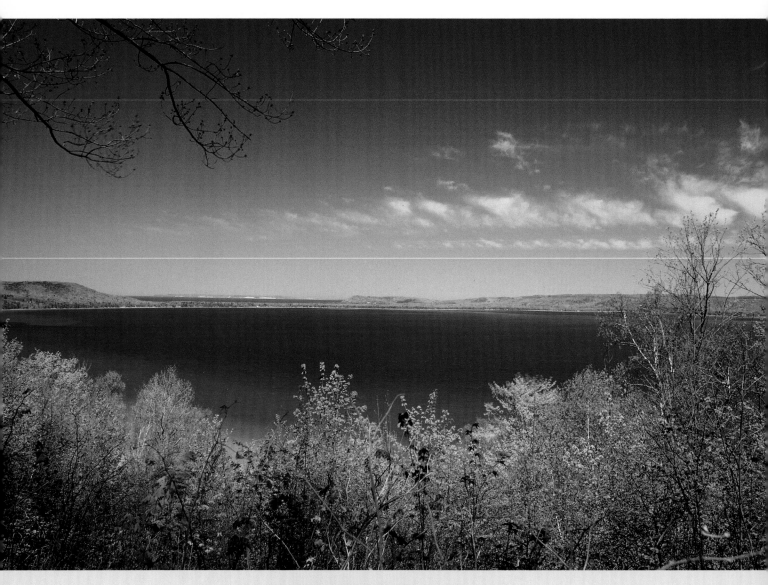

Glen Lake overlook from Inspiration Point

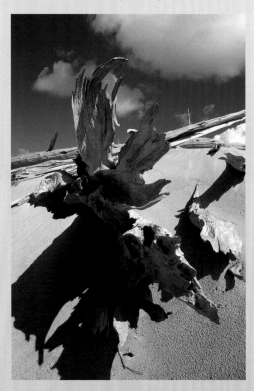

The Ghost Forest

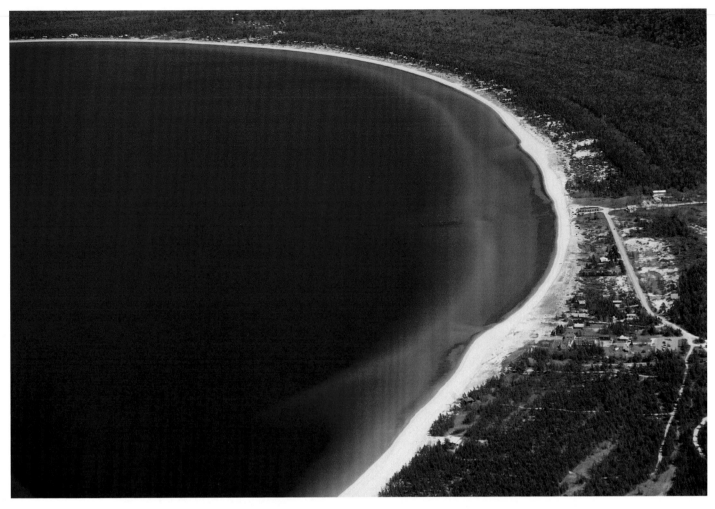

Looking down to Glen Haven from above Sleeping Bear Point

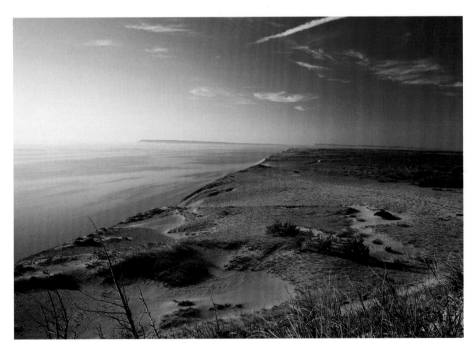

North slope Ghost Forest blow-out

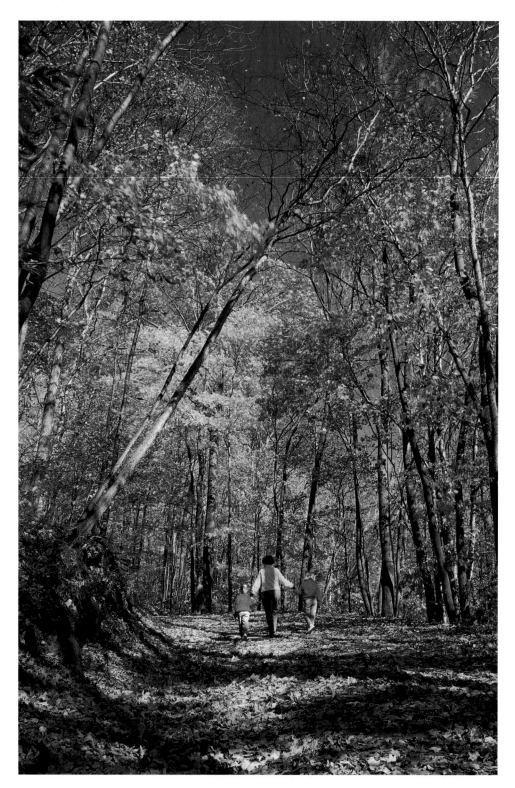

Trail to Pyramid Point

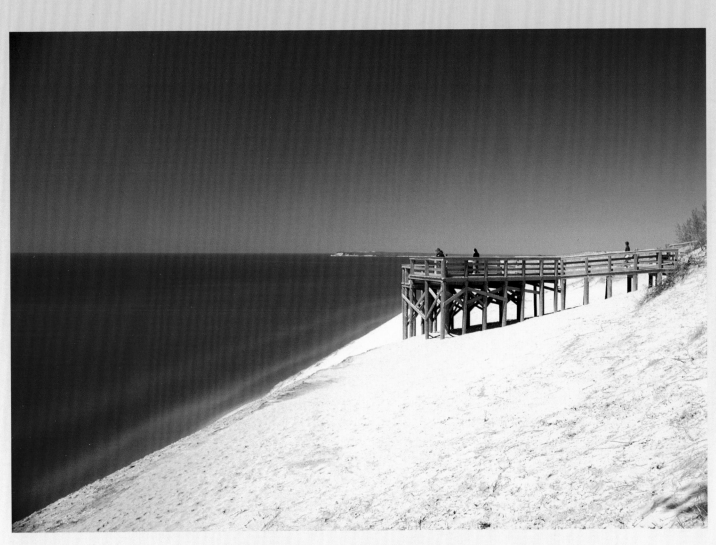

Lake Michigan overlook from Pierce Stocking Drive (South Manitou in the background)

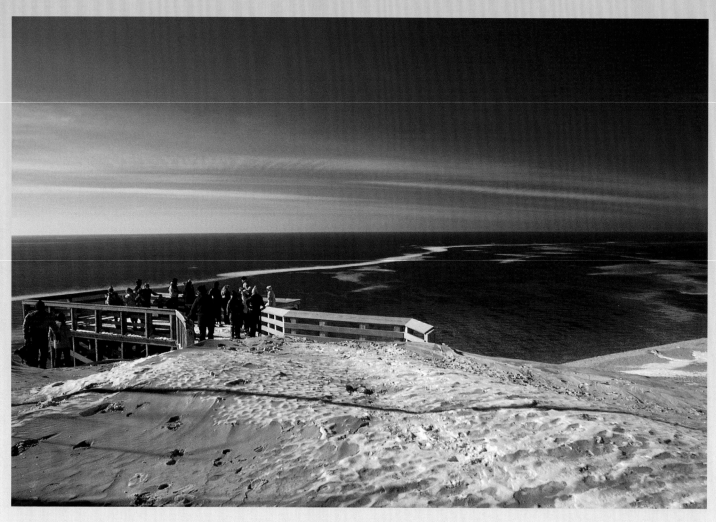

Winter at the overlook

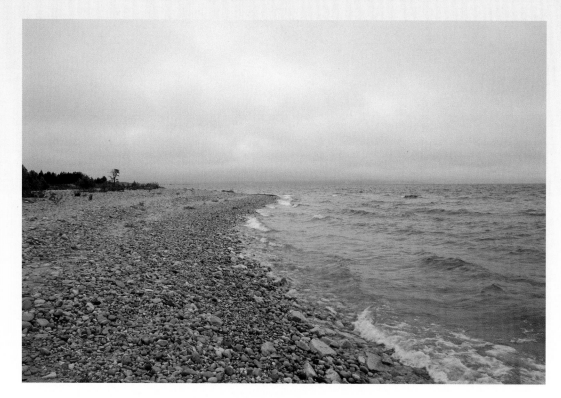

Sleeping Bear Point

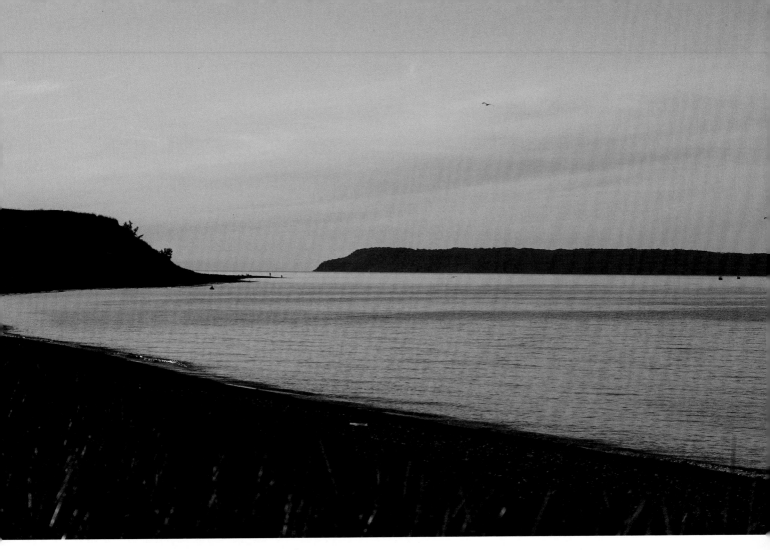

Evening at Sleeping Bear Point and South Manitou

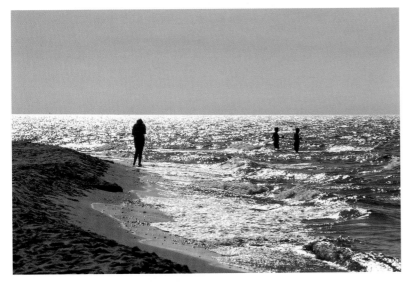

Platte Beach

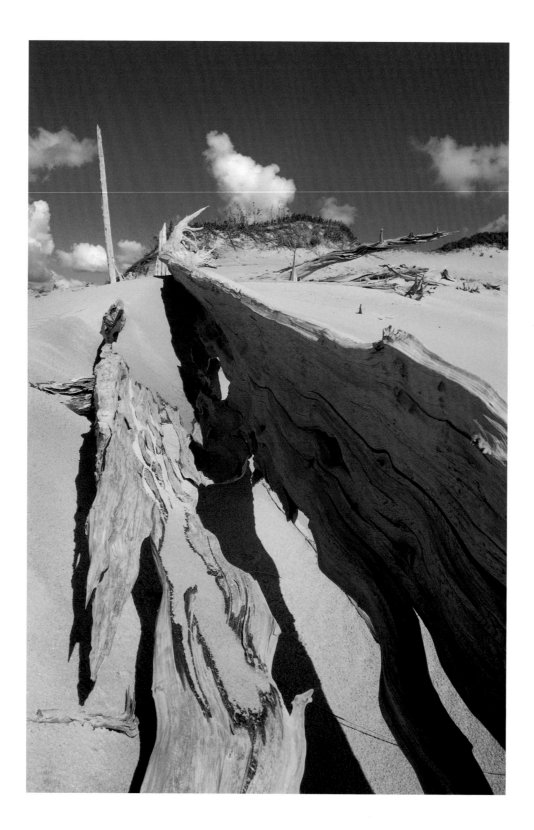

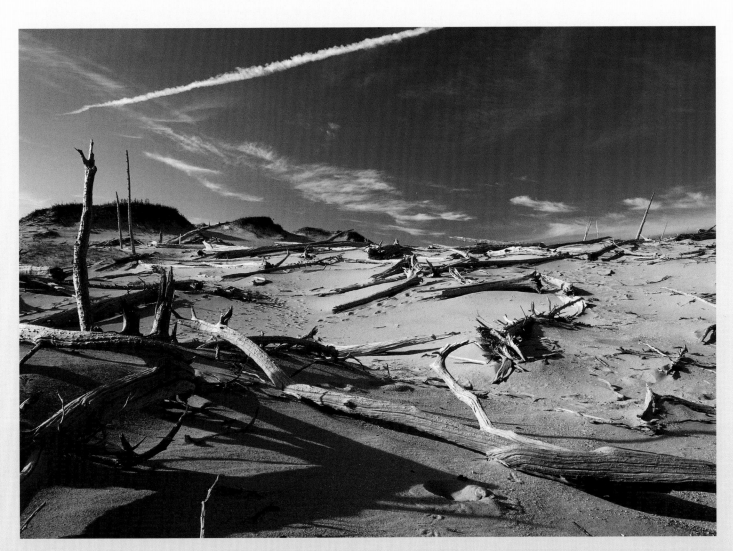

Gnarled cedars, uniquely twisted by the elements of the dunes in the Ghost Forest

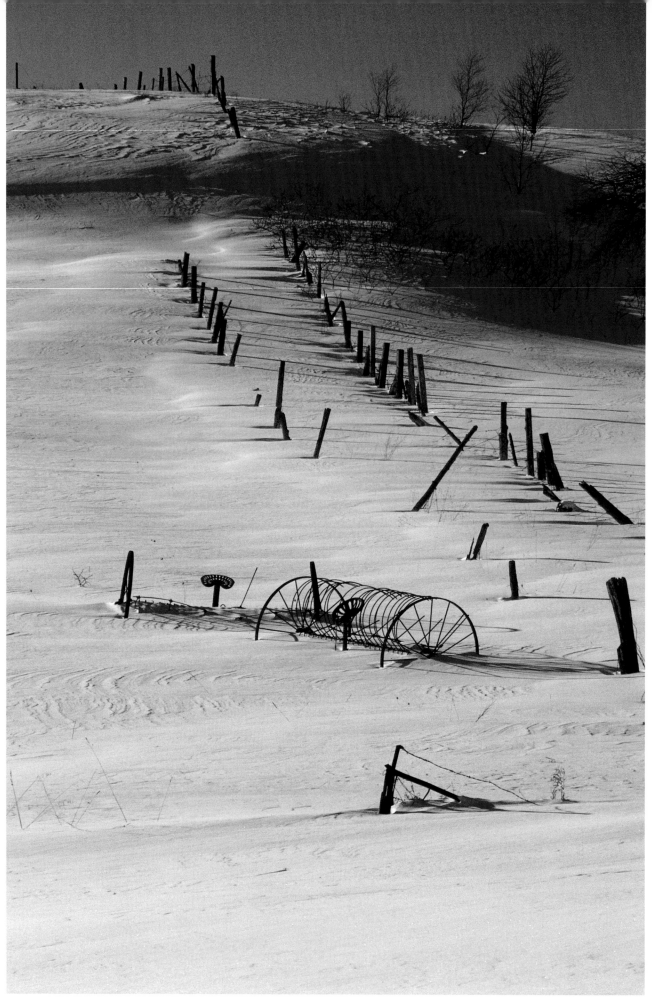

Remnants of a farm's fence line

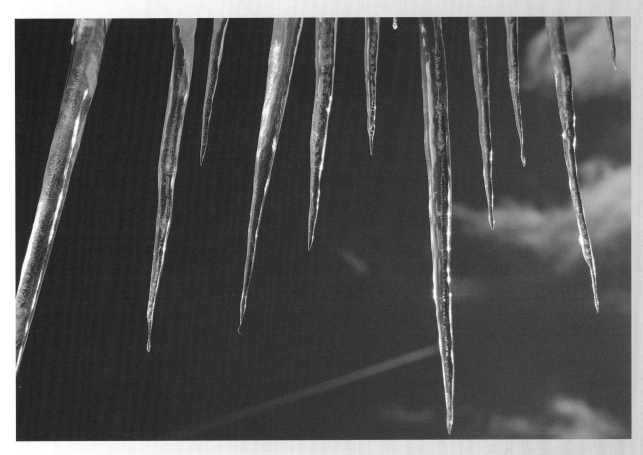

Winter along the lakeshore

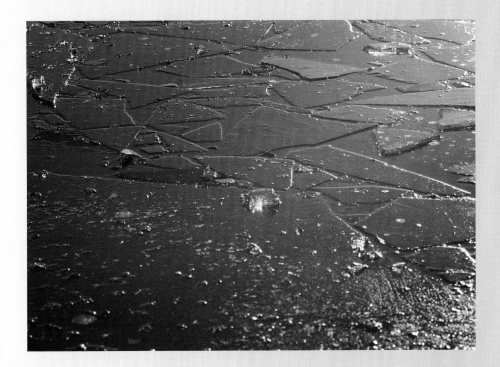

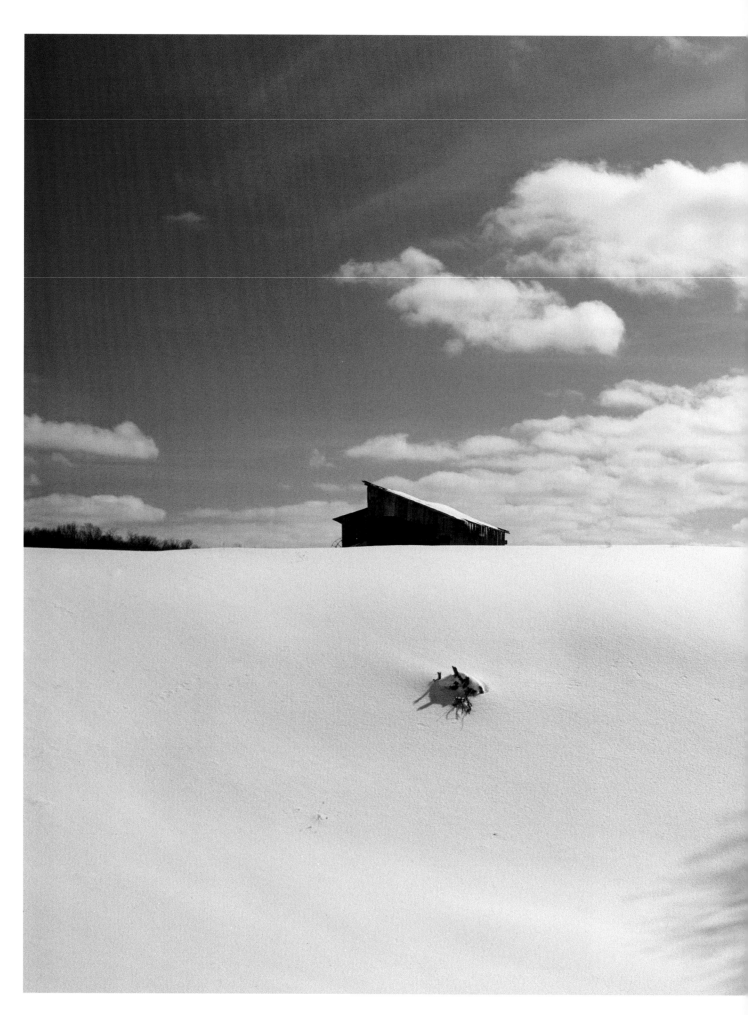

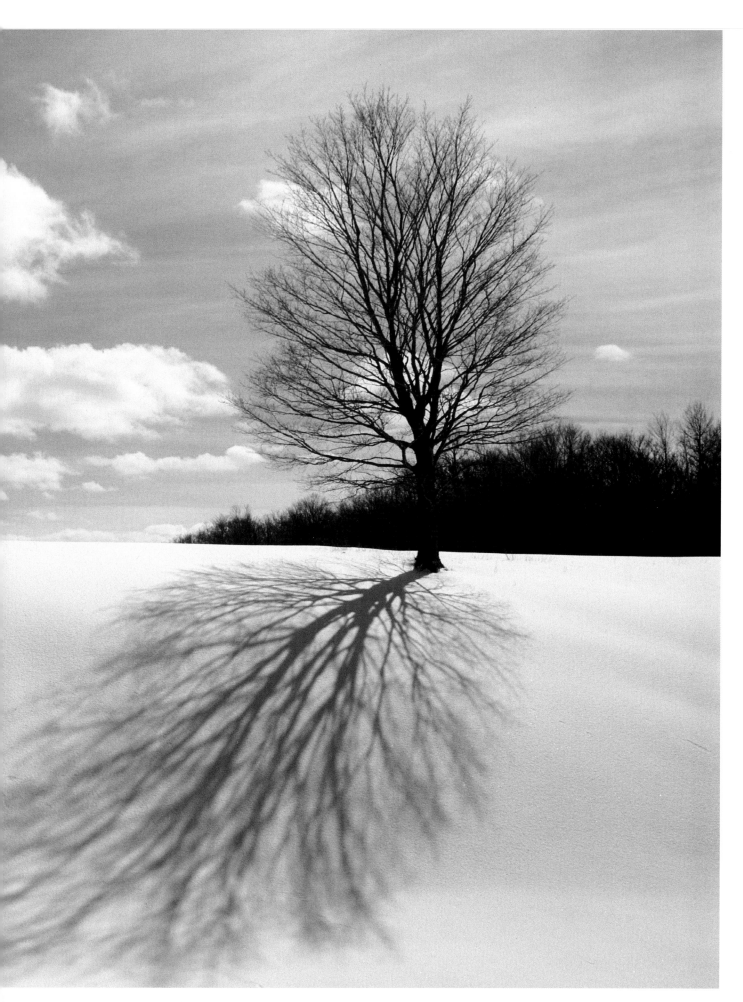

Winter solstice just east of Empire

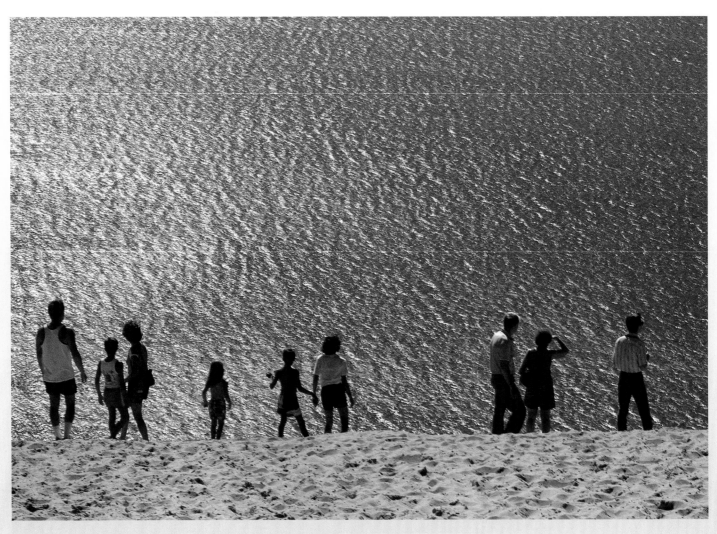

A view worthy of the climb

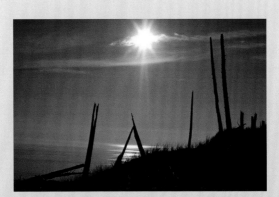

North of the overlook

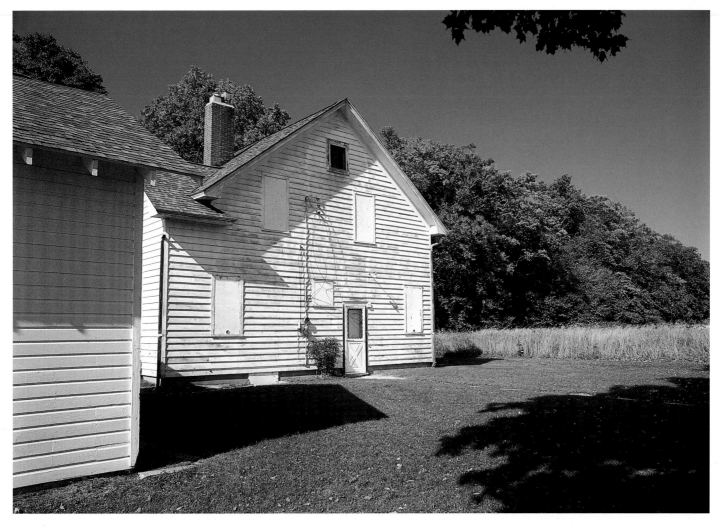

Farm at Port Oneida

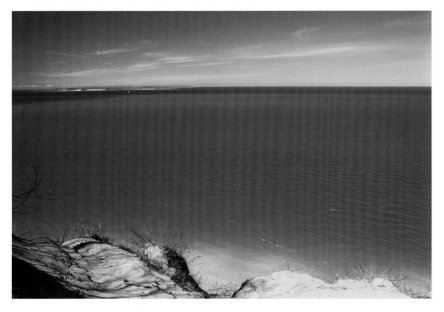

Pyramid Point

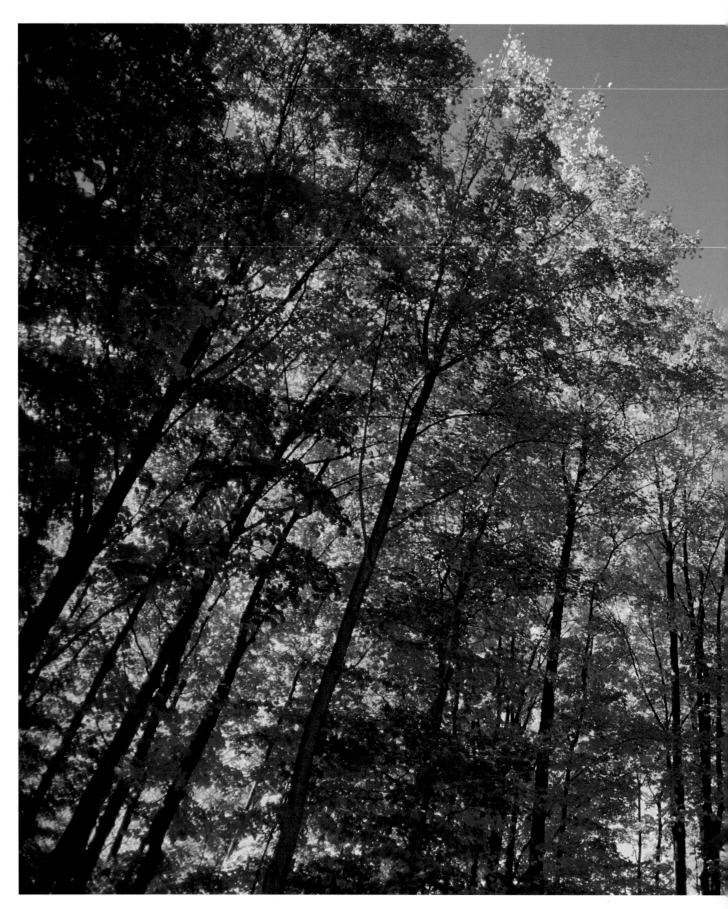

Sweet whispers of autumn

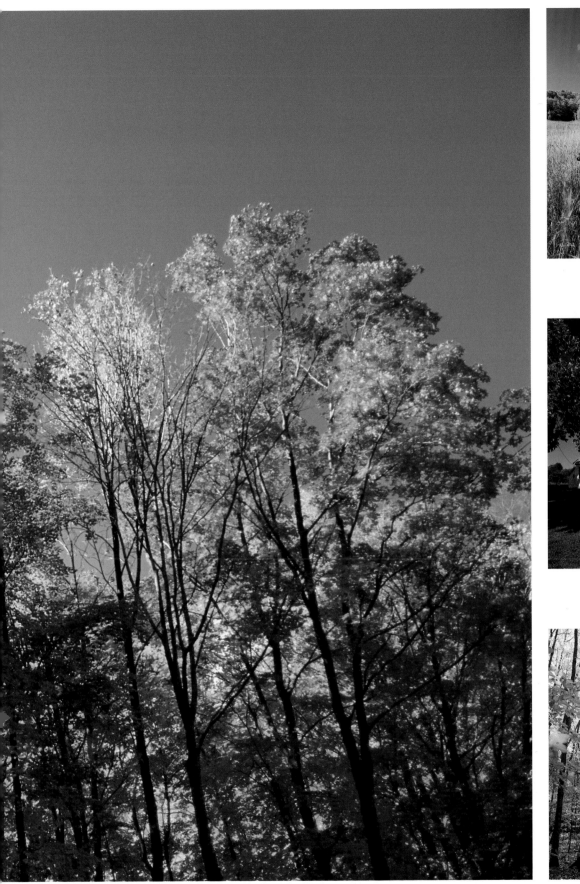

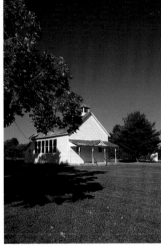

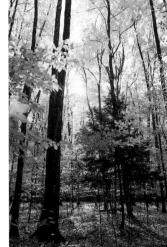

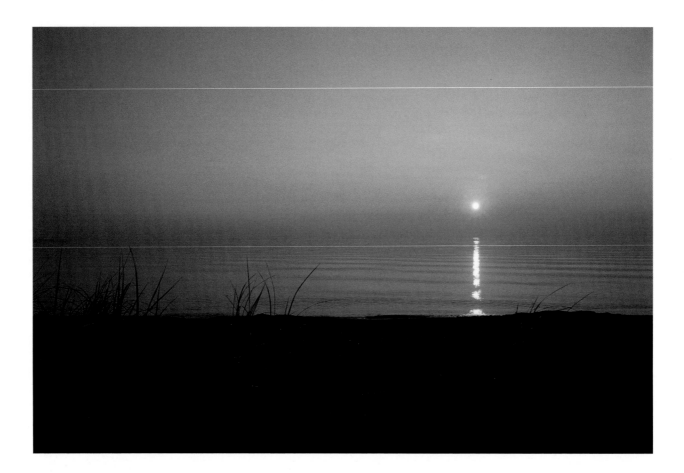

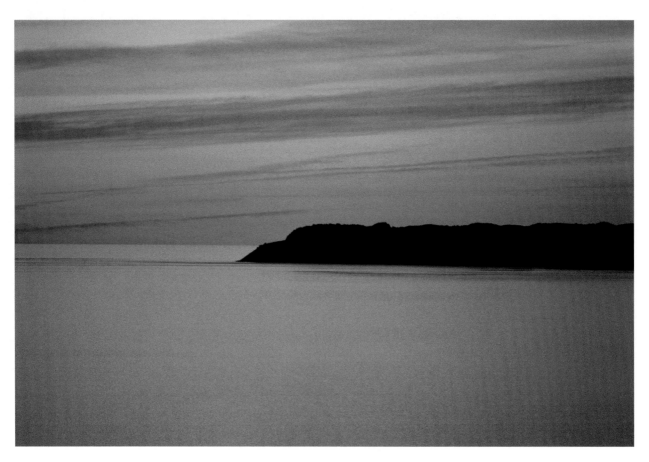

No matter what the season, sunsets at Sleeping Bear are worth the journey

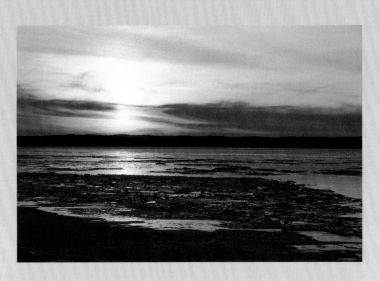

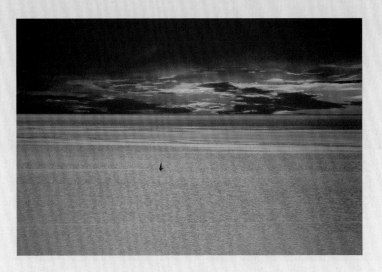

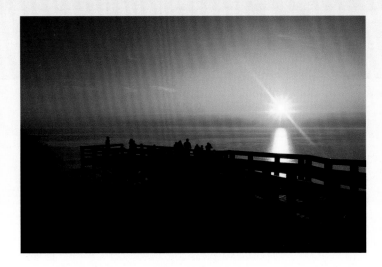

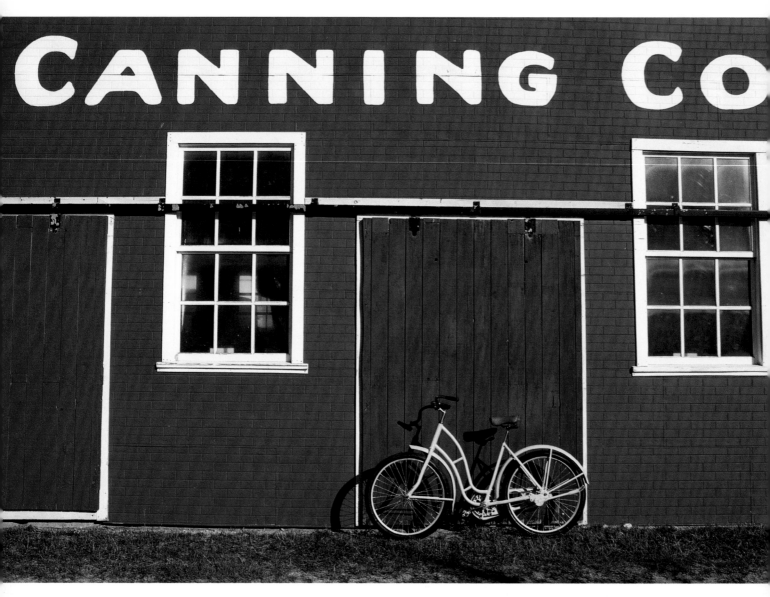

The old Glen Haven Canning Company, now the Maritime Museum

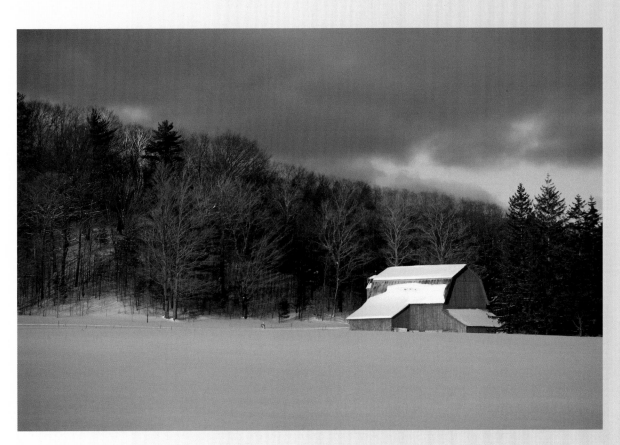

An old barn at Port Oneida

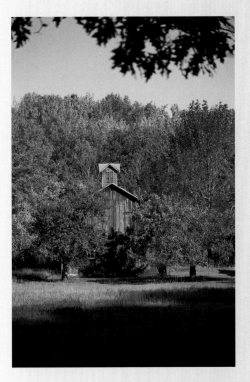

A barn near Good Harbor Bay

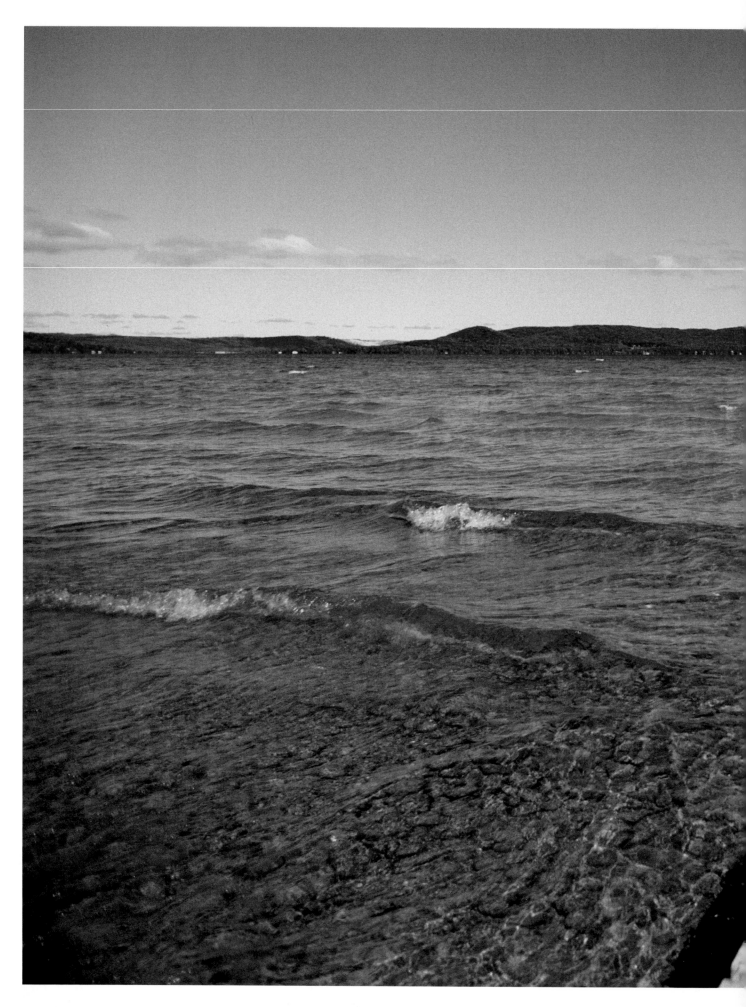

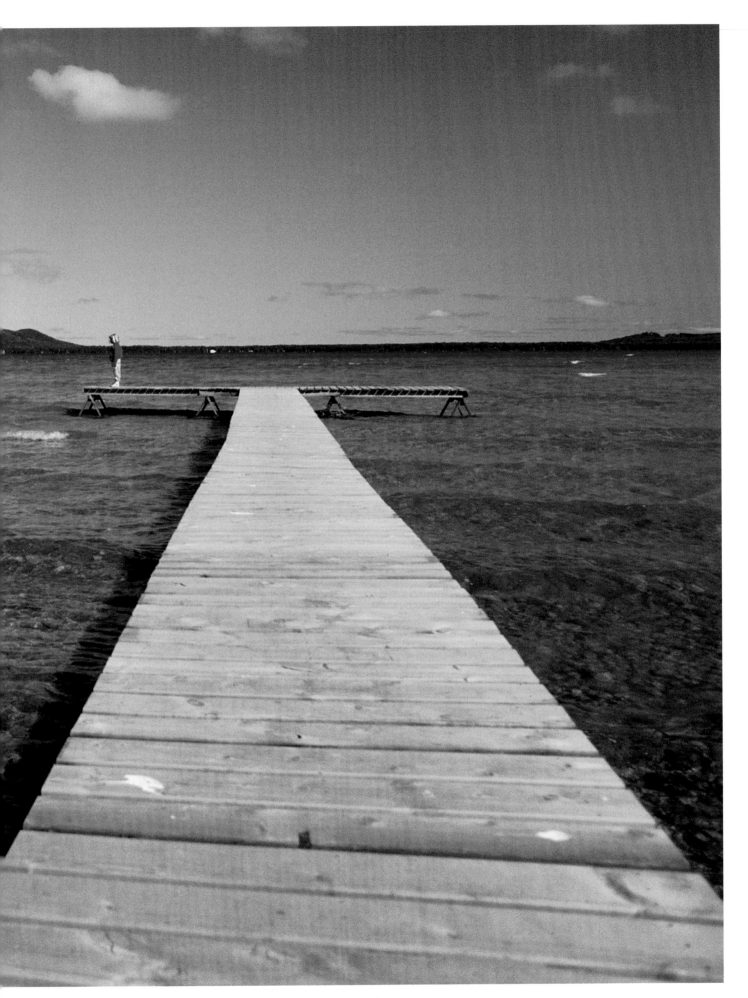

A brisk sunny afternoon on Big Glen Lake

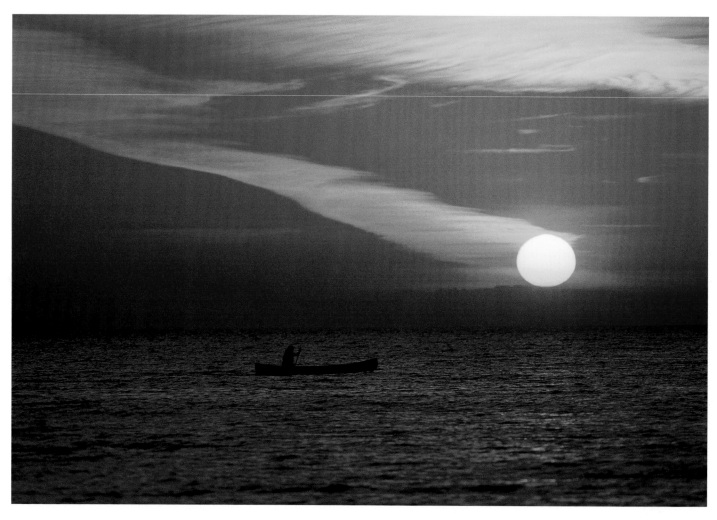

Paddling along Aral Beach

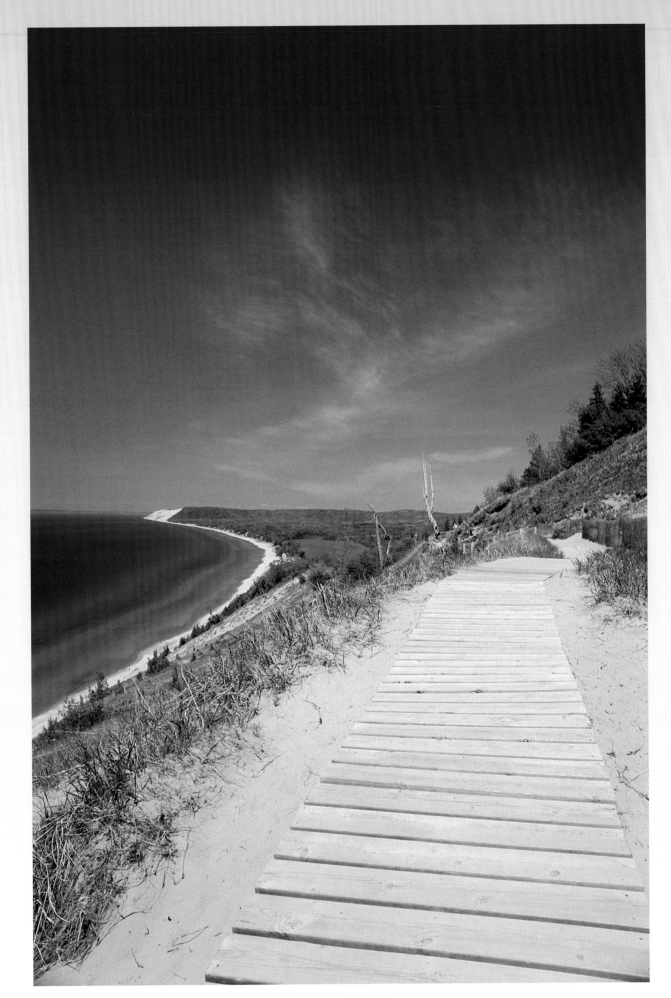

Empire Bluff Trail

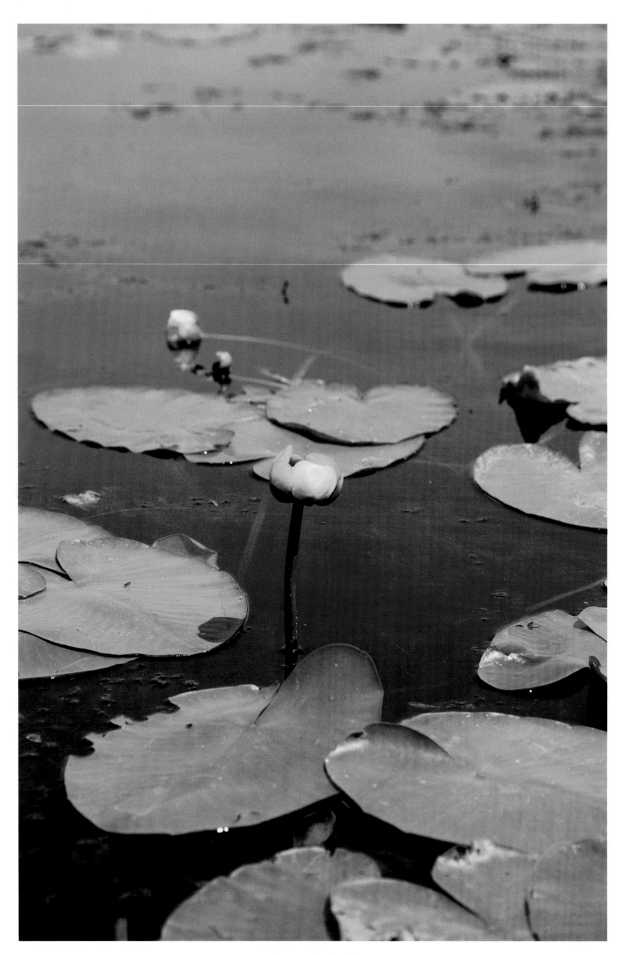

Lillies at School Lake

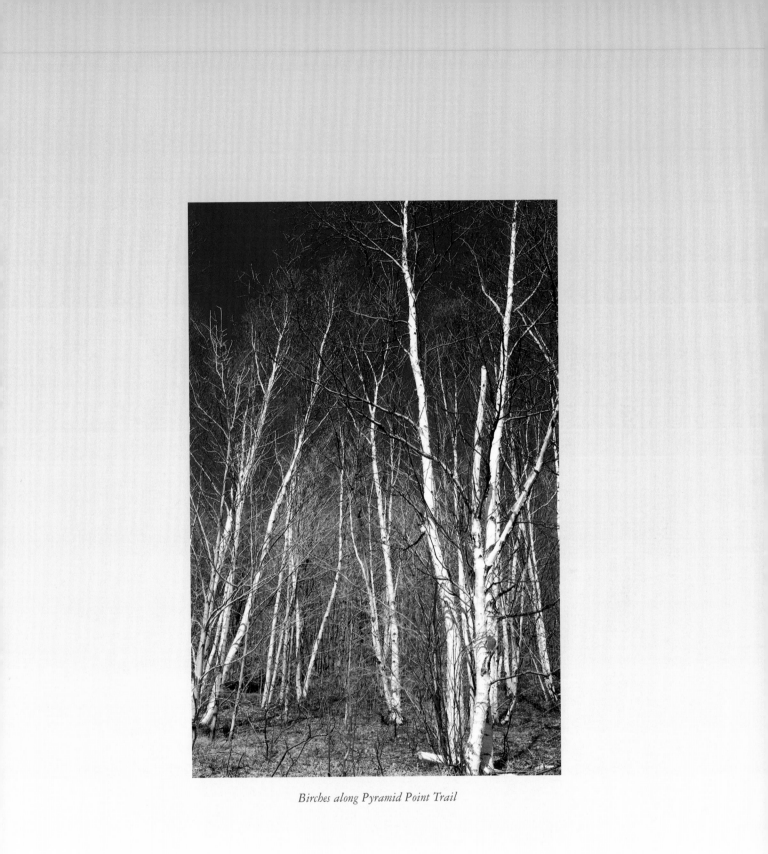

Birches along Pyramid Point Trail

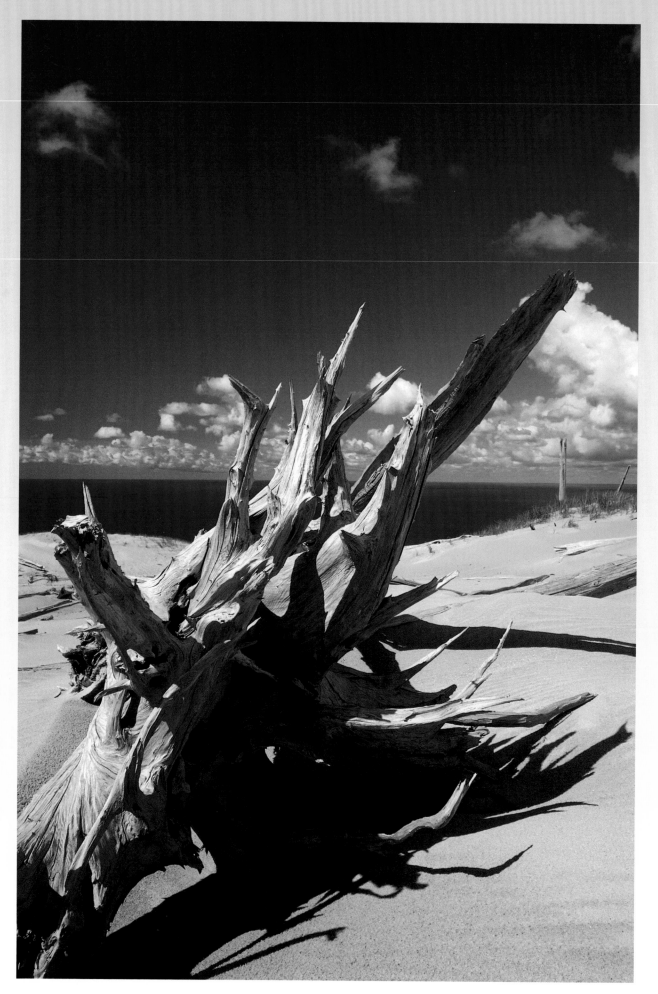

The sun-bleached roots of a cedar in the Ghost Forest

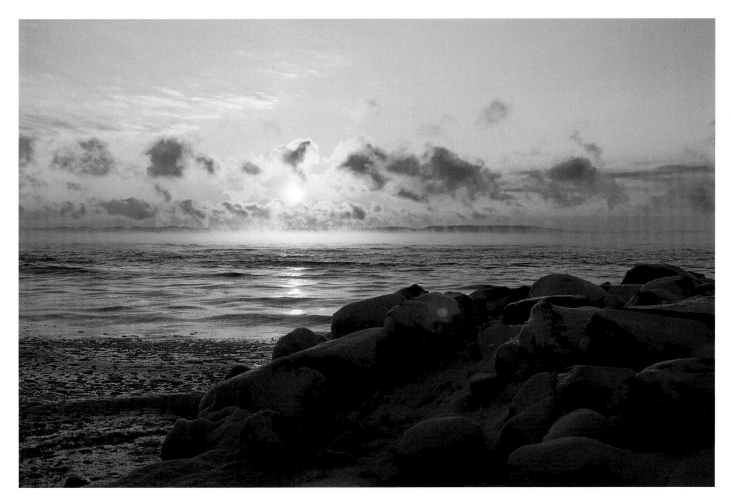

A cold winter sunset at Good Harbor Bay near Whaleback

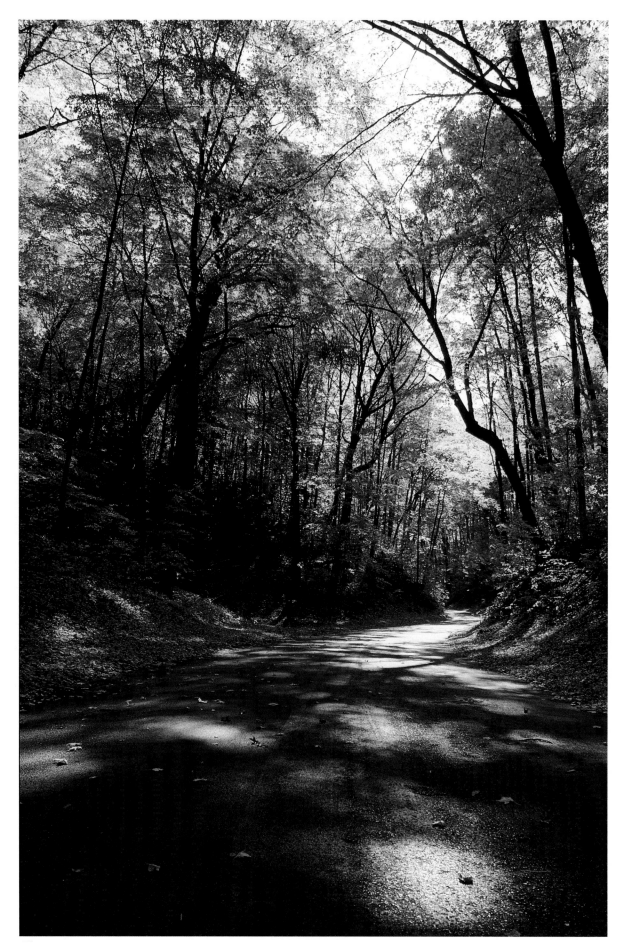

From Empire to the Bluffs Trail head

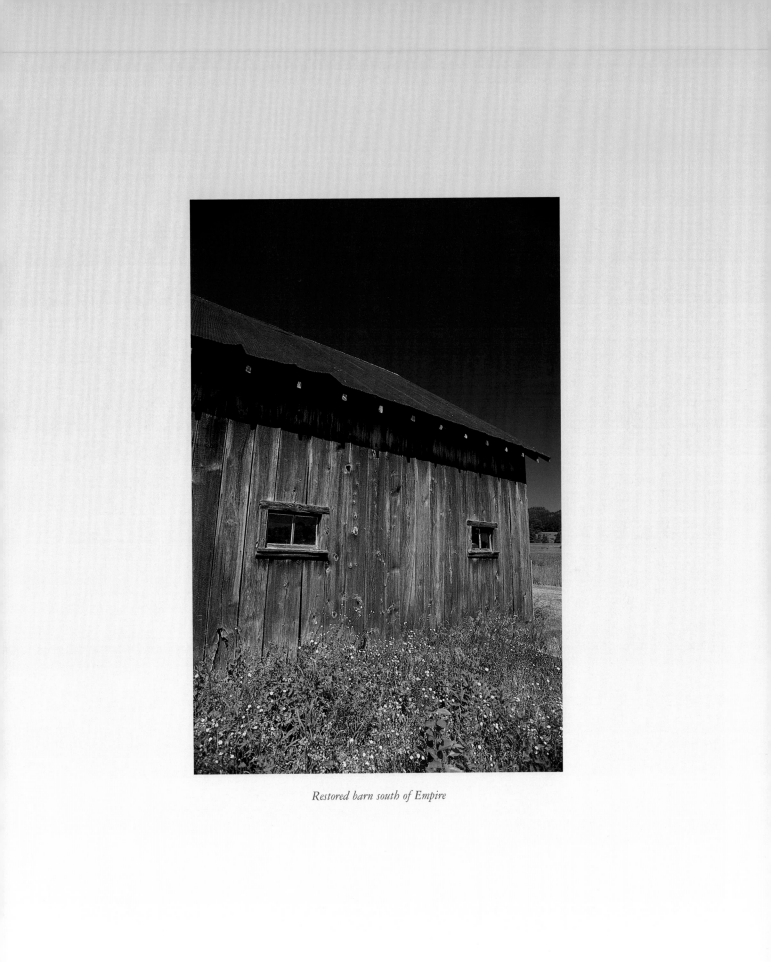

Restored barn south of Empire

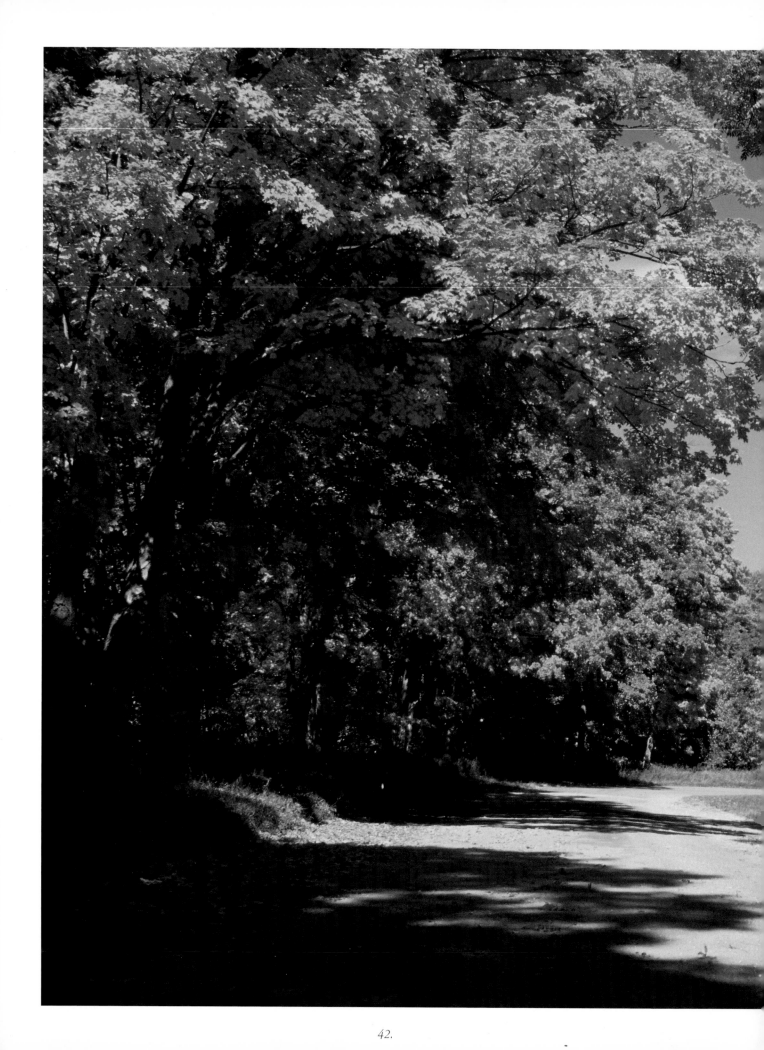

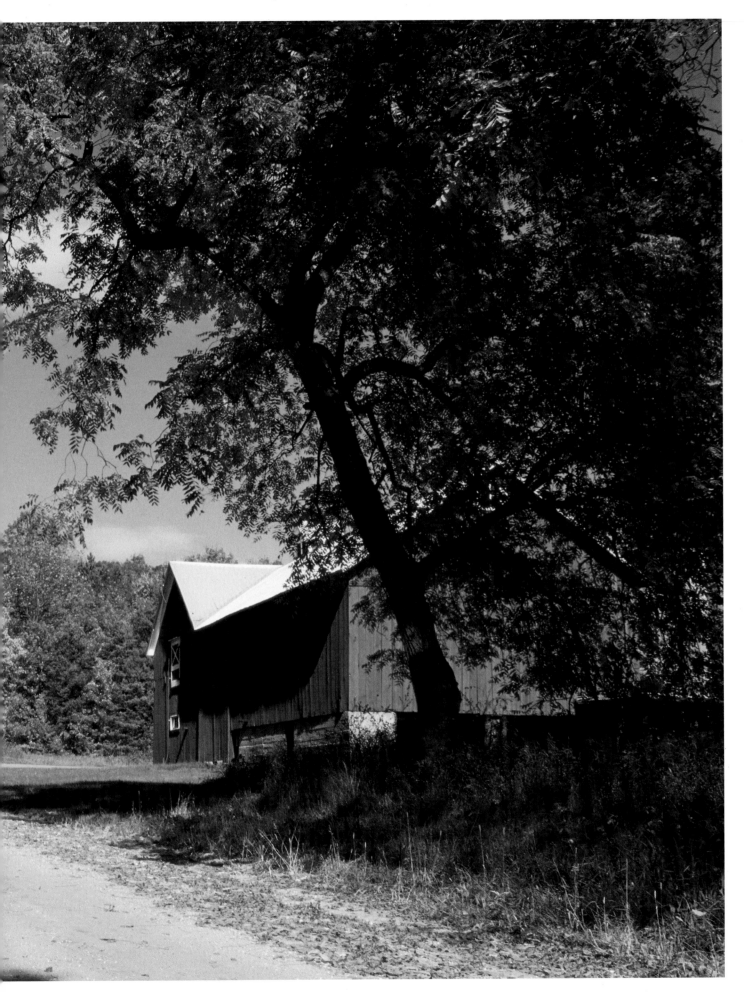

Norconk Road just south of Empire Bluffs

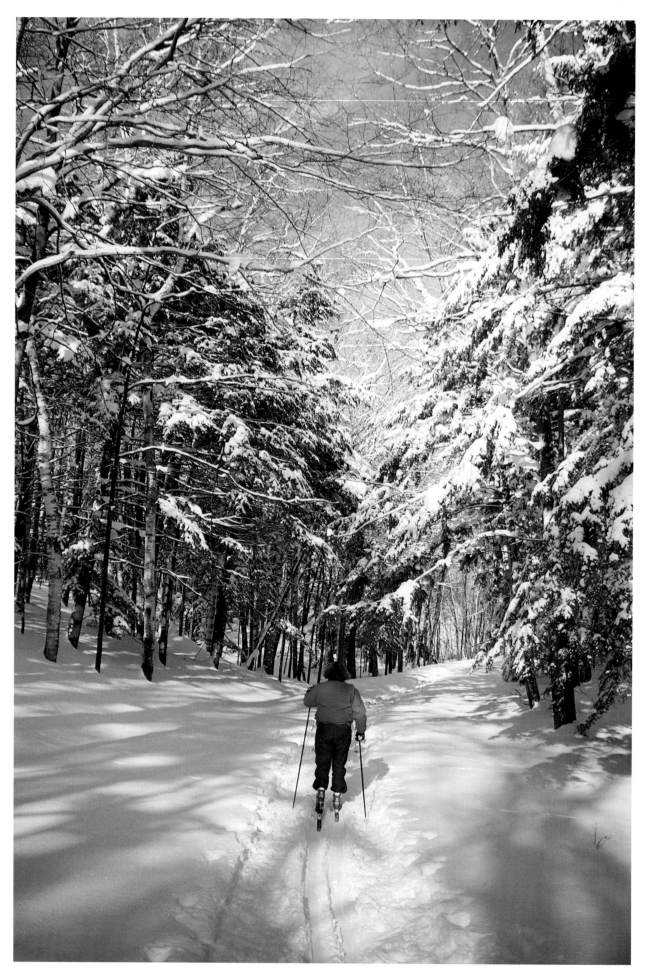

Alligator Hill Trail

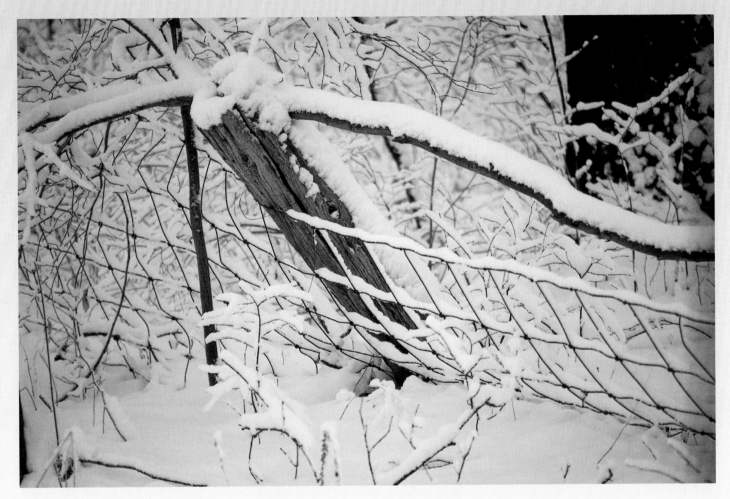

Winter beating down one of the last bygone fences

Following page:
Winter ice below the overlook
with South Manitou in the far right

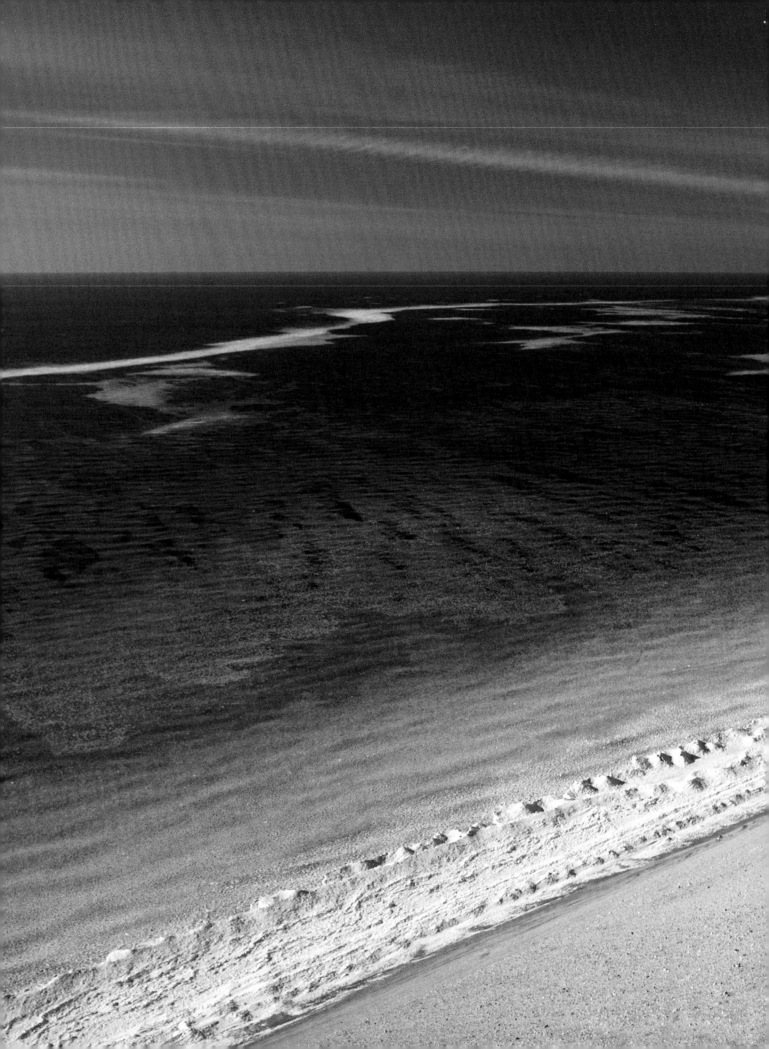

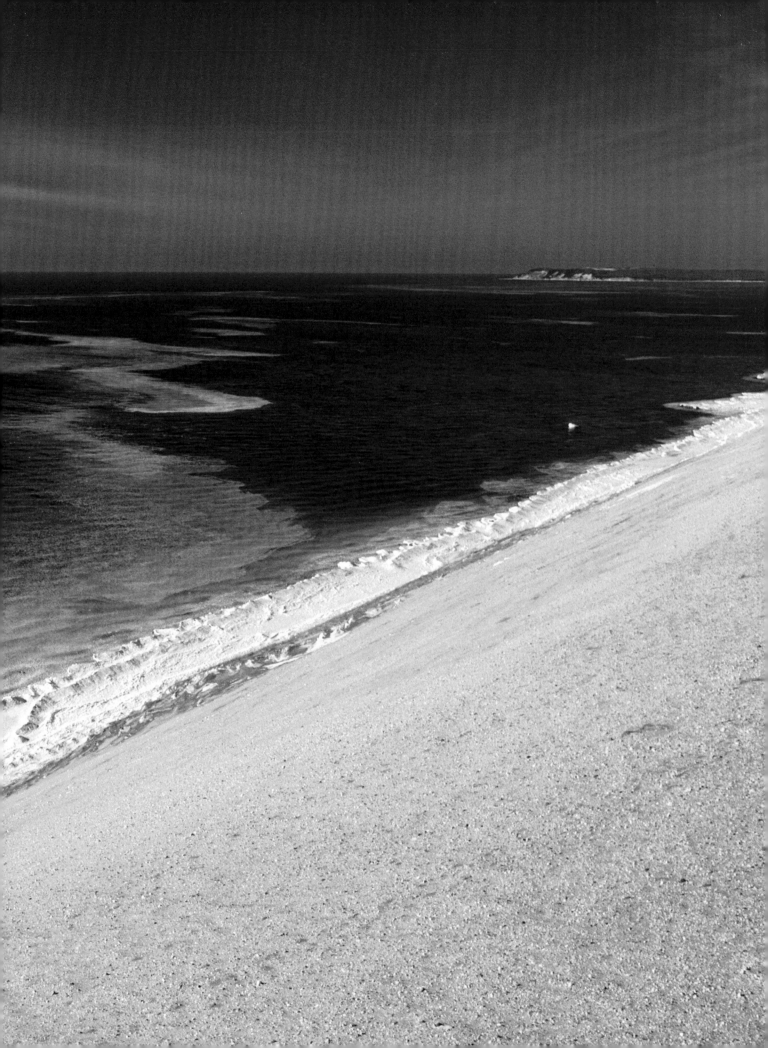

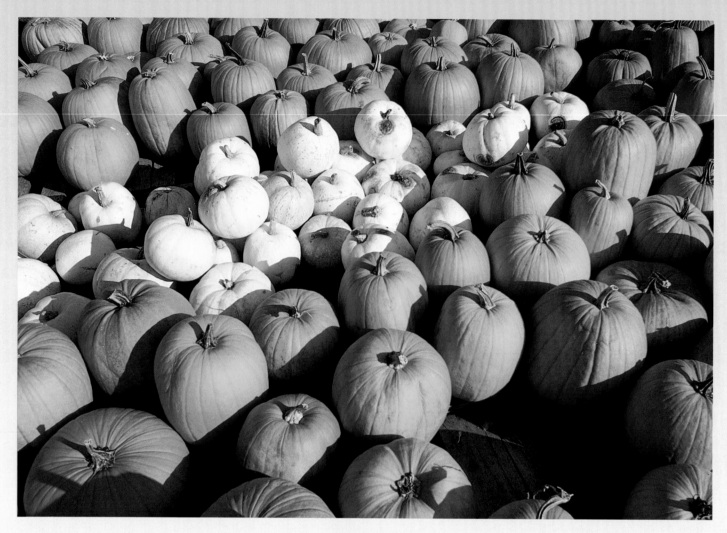

Autumn in the park

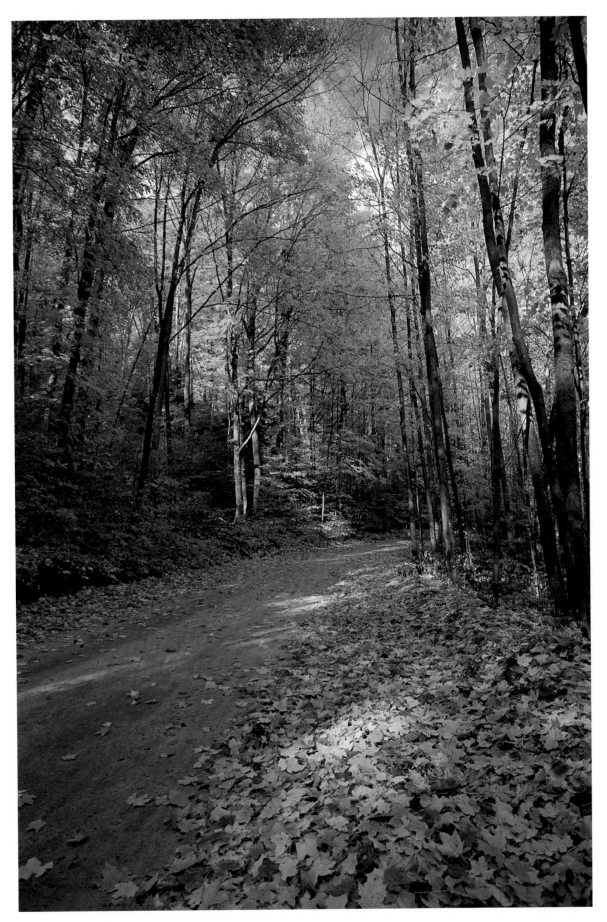

Along Hills Road to Aral

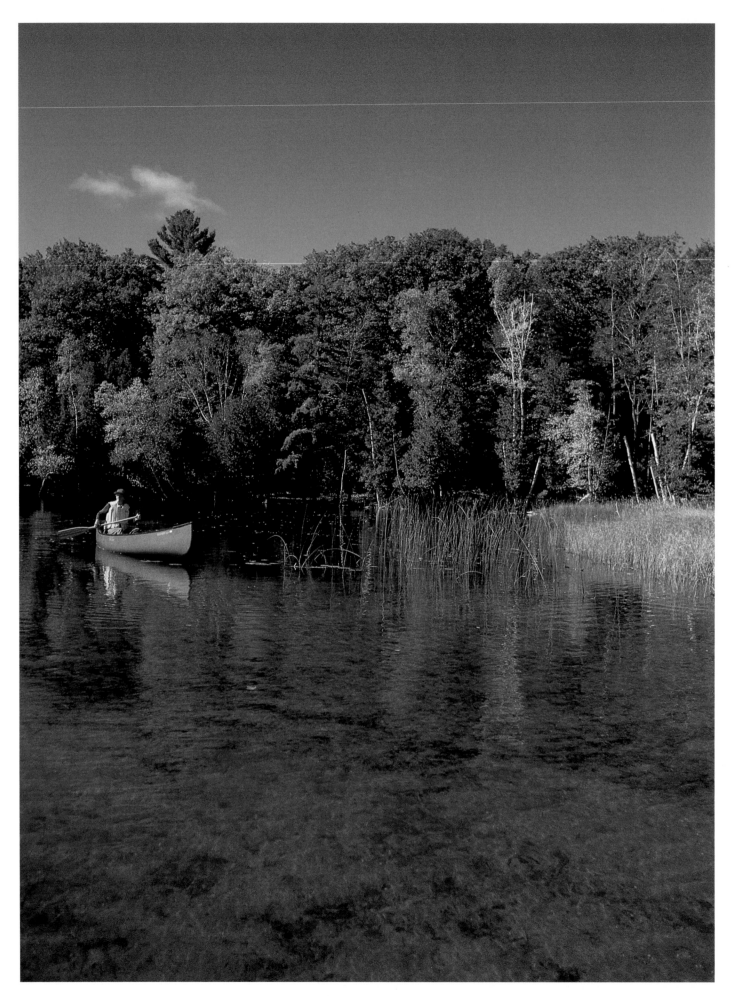

Canoeing on Bass Lake

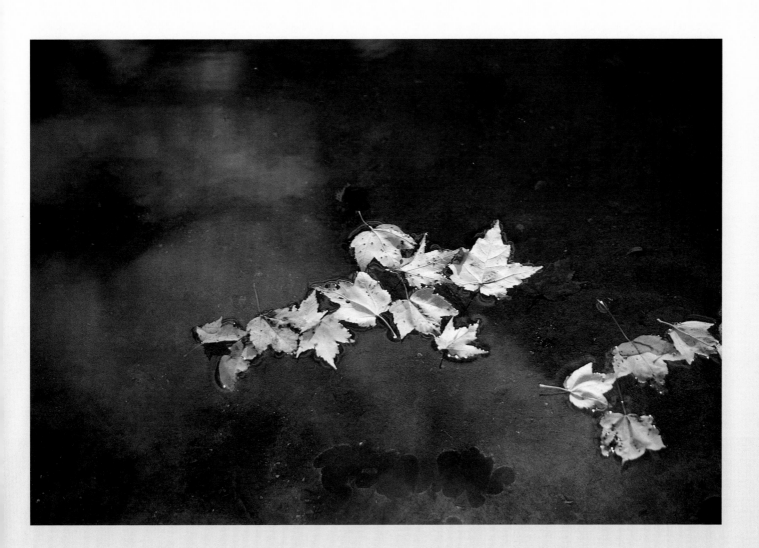

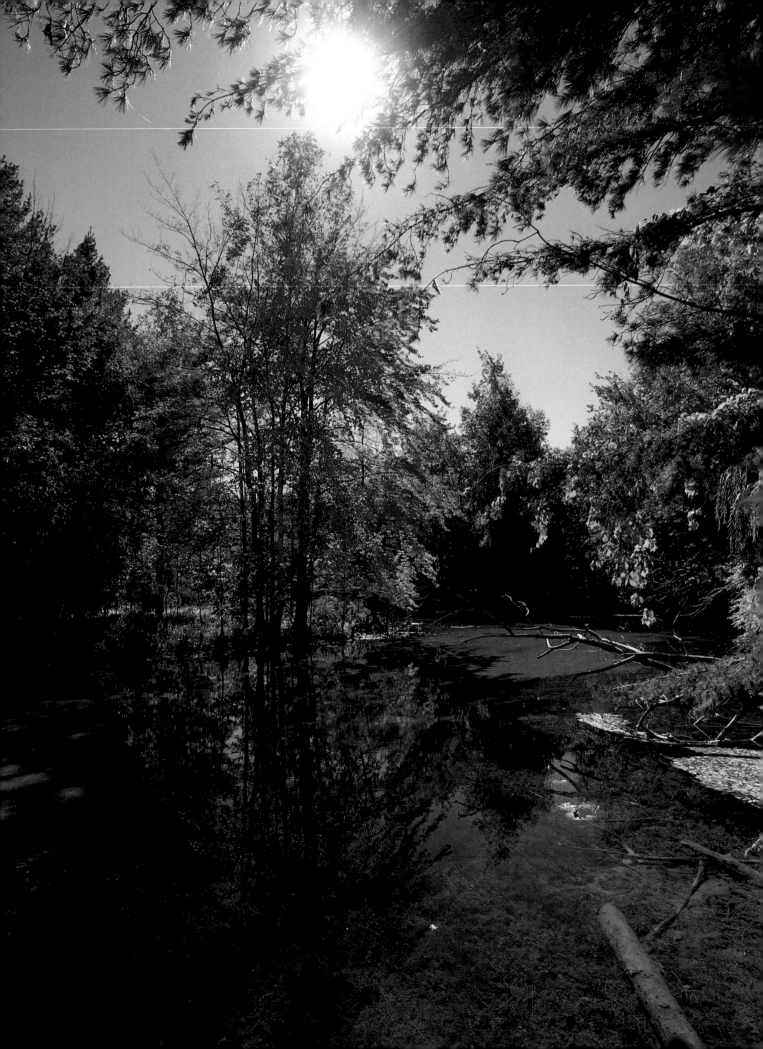

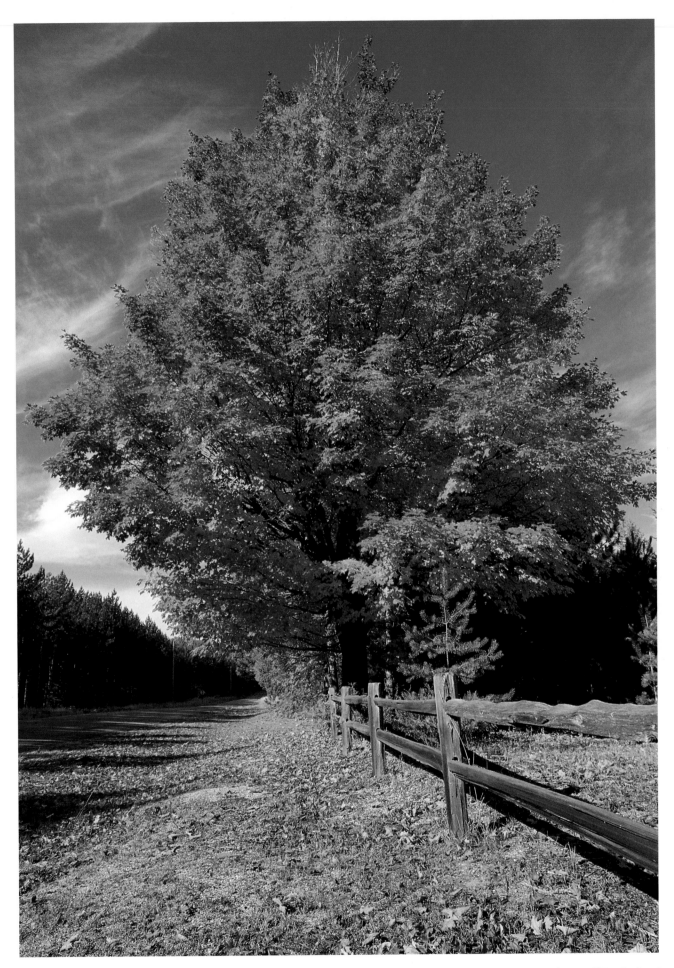

Opposite page:
Near the headwaters of the Crystal River

A crimson maple just off Fowler Road

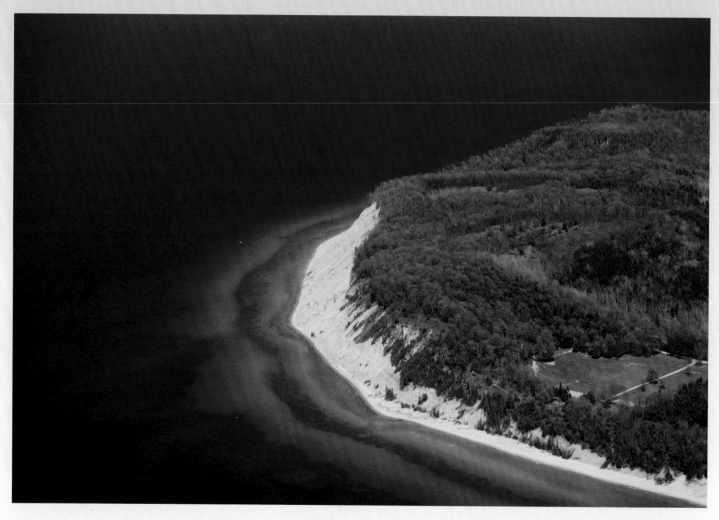

Pyramid Point from the air

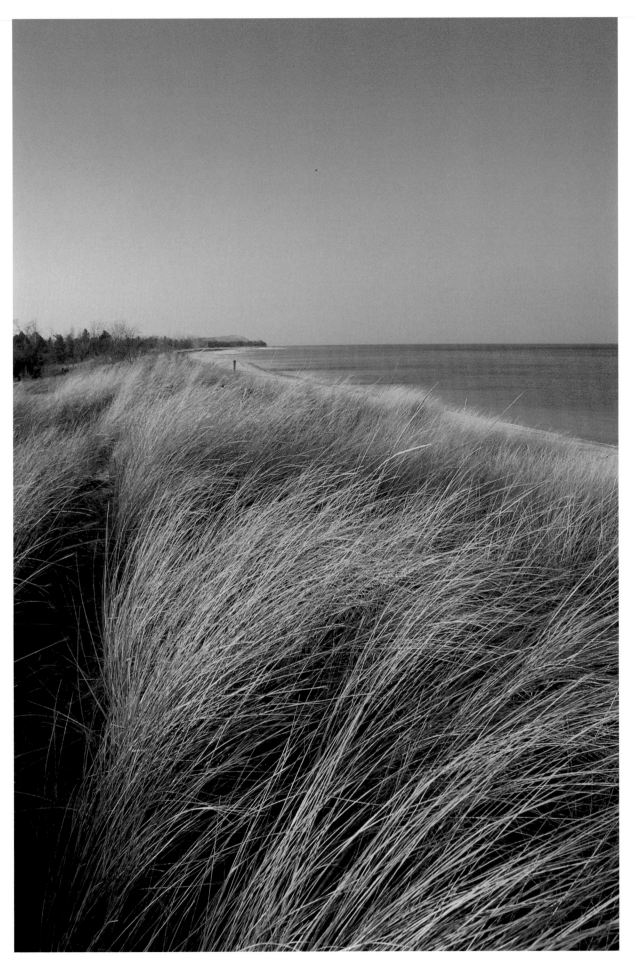

Dune grass along Glen Haven's shores

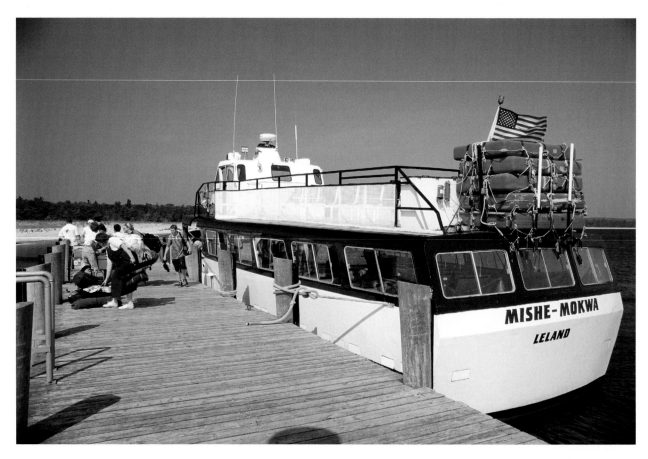

South Manitou dock

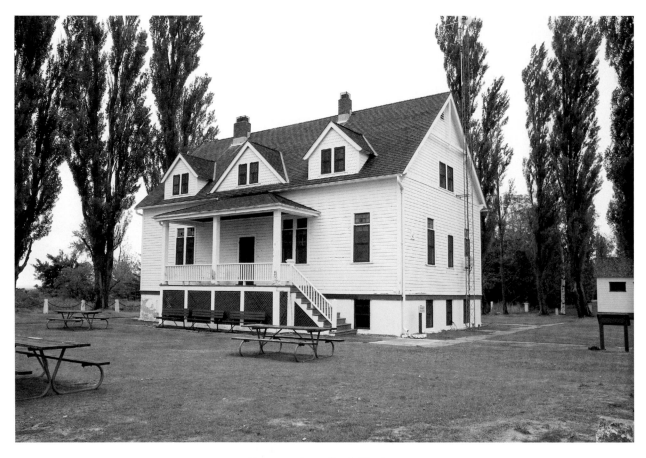

Ranger station on South Manitou

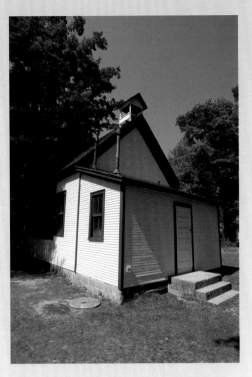

The old village schoolhouse on South Manitou

Barn restoration on South Manitou

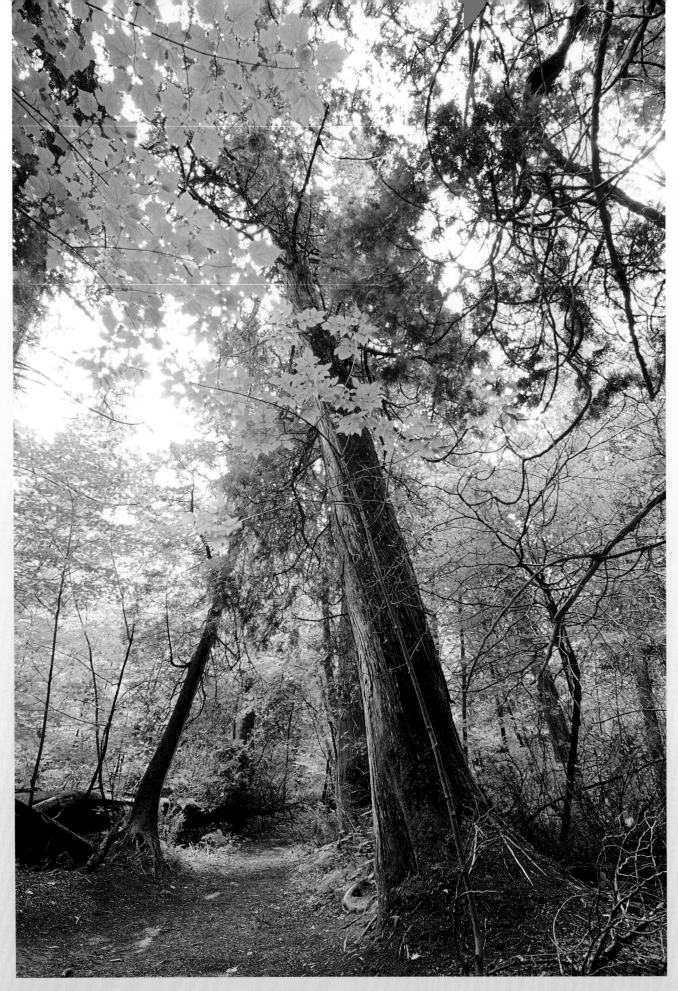

The giant cedars on South Manitou

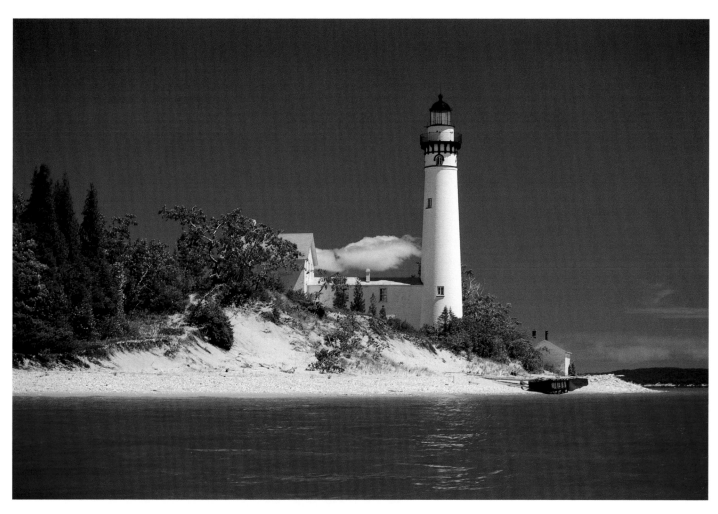

The lighthouse on South Manitou

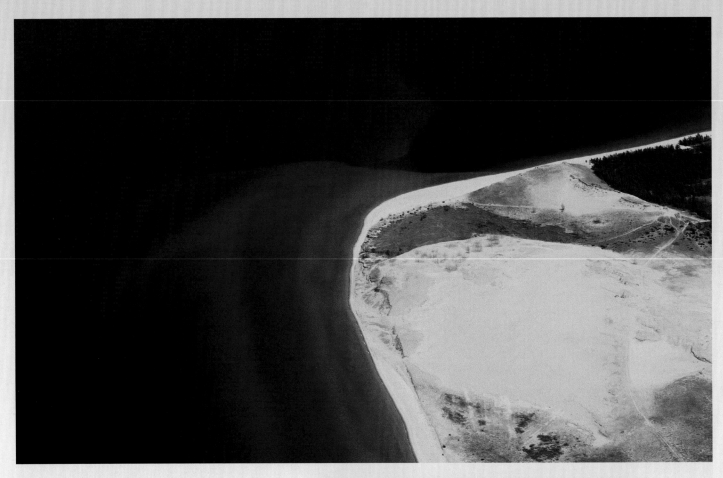

Sleeping Bear Point from the air

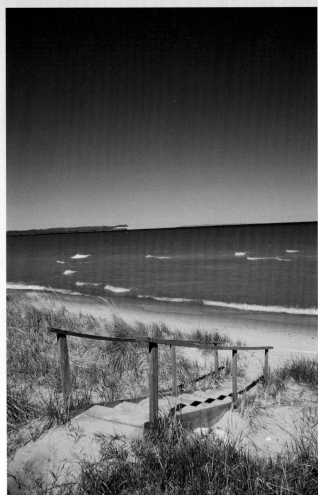

One of the many cottage walkways on Good Harbor Bay with Pyramid Point on the horizon

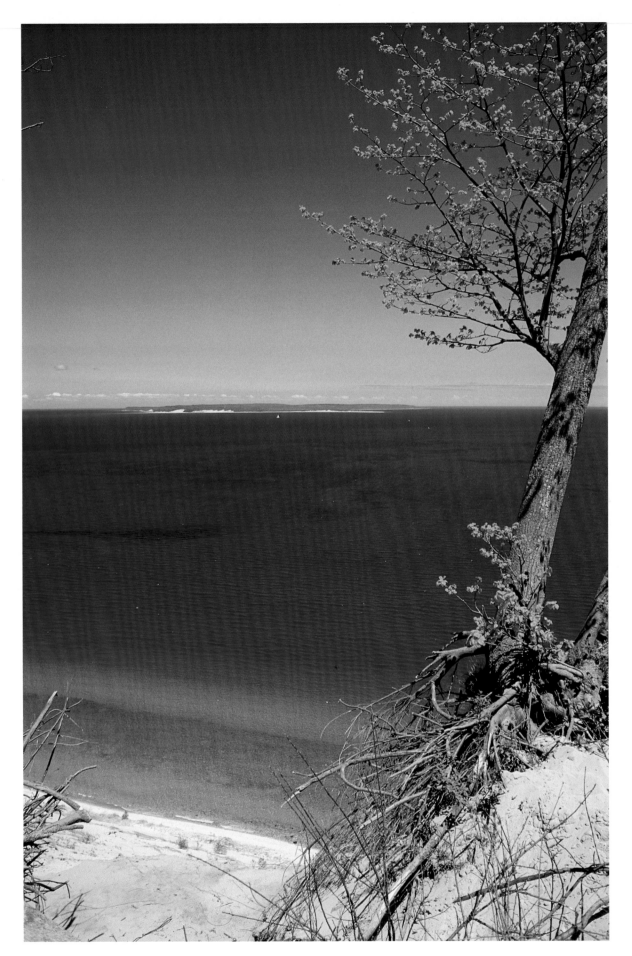

North Manitou from Pyramid Point

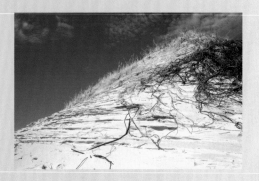

Root snags along eroding dunes

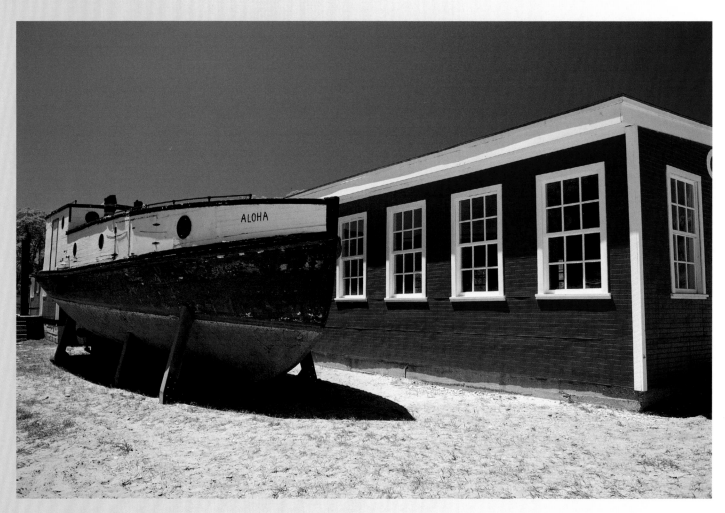

Glen Haven Maritime Museum

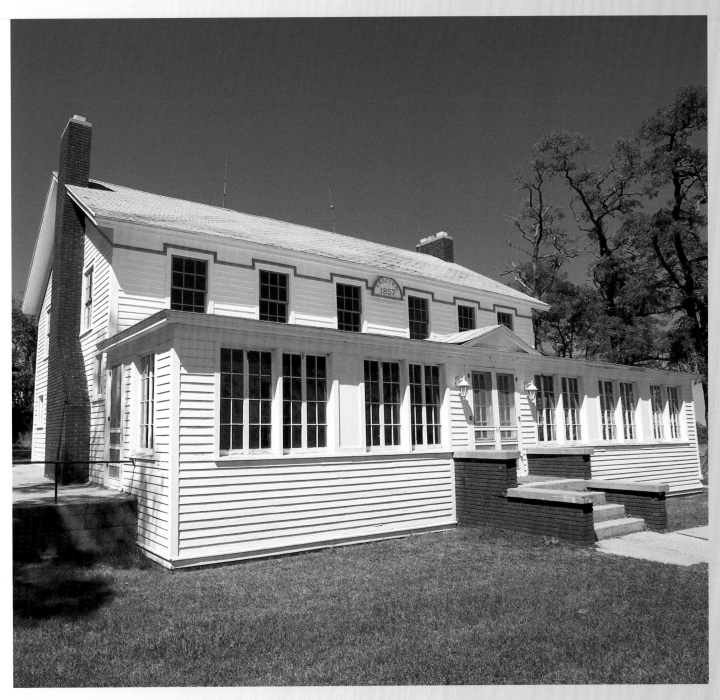

The old inn at Glen Haven

Following page:
Inside the old rescue station
at Glen Haven

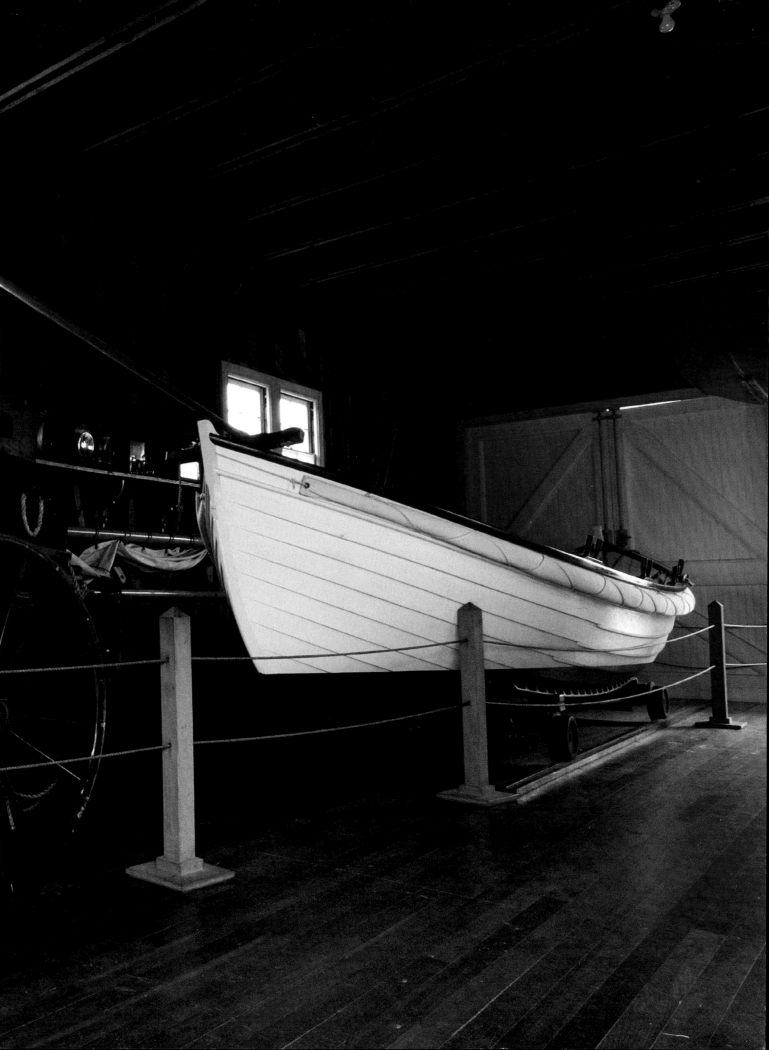

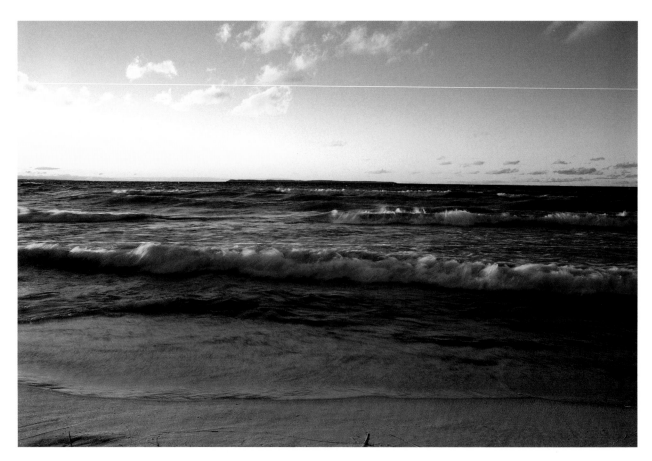

One of the many northwesters to hit the shore at Good Harbor Bay

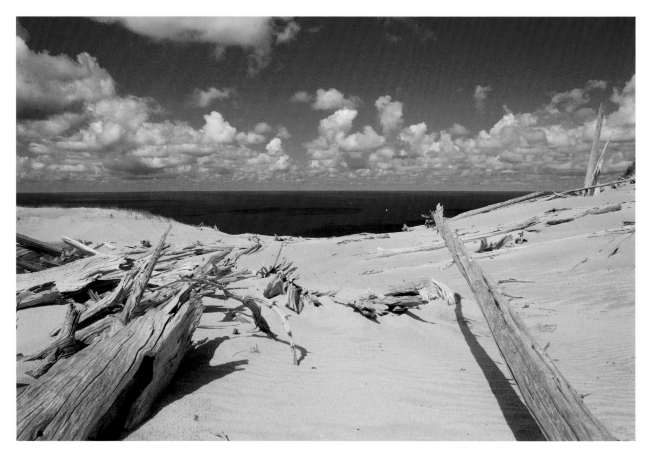

Twisted cedars in the Ghost Forest

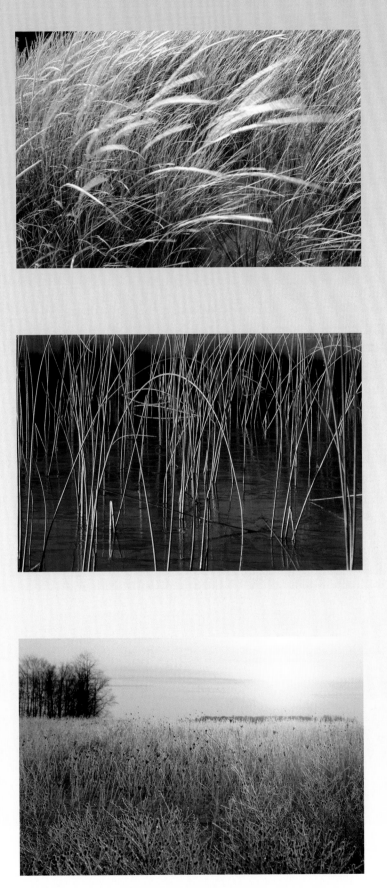

The lakeshore mystic moods

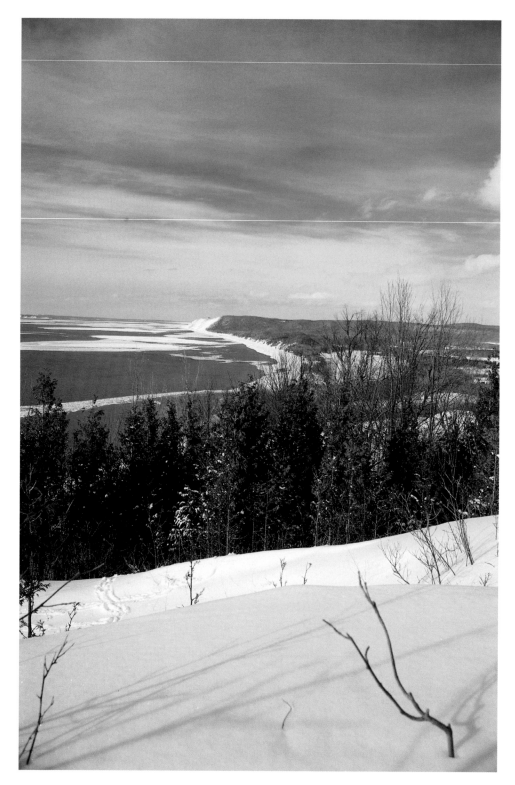

Trail's end on Empire Bluffs

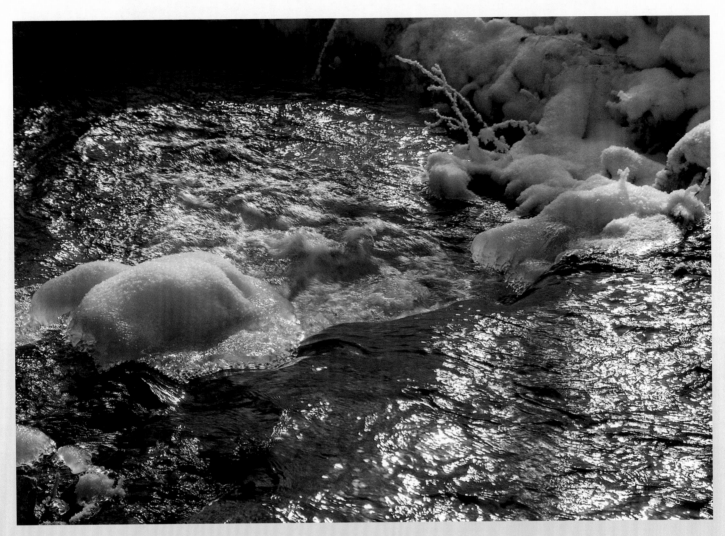

Shalda Creek

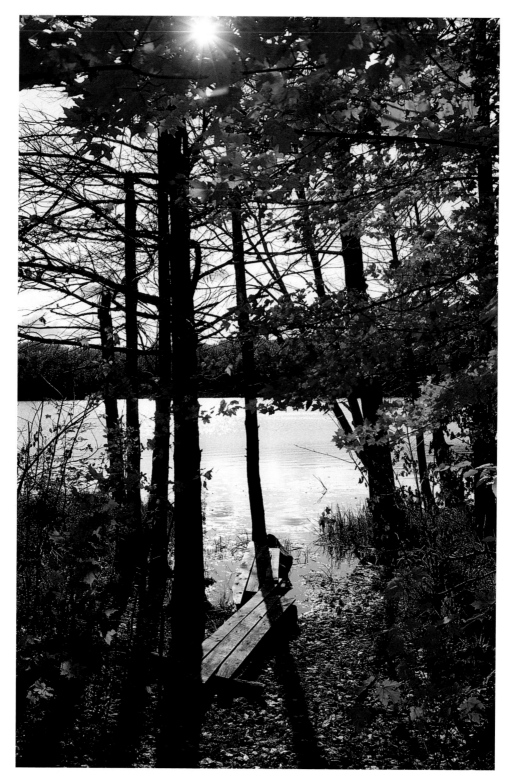

A tricky walk down the dock on School Lake

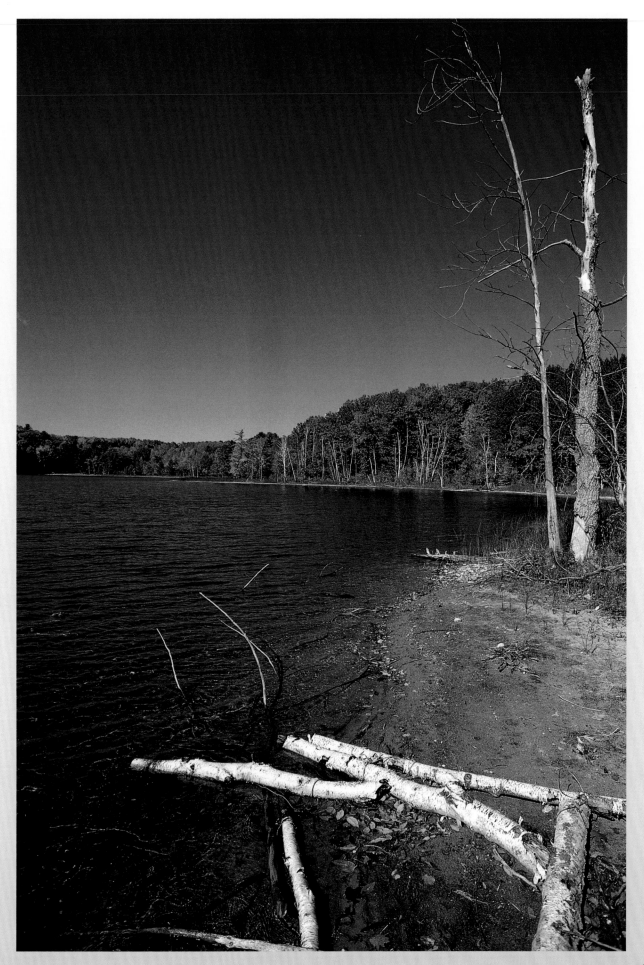

Shell Lake

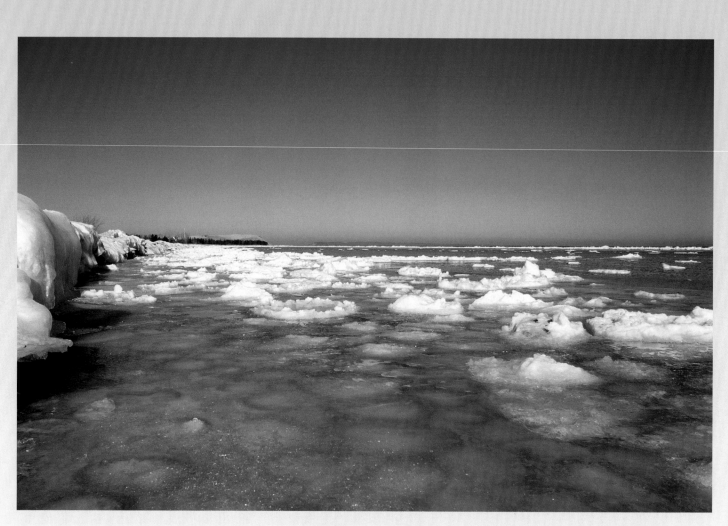

Sleeping Bear Point in winter

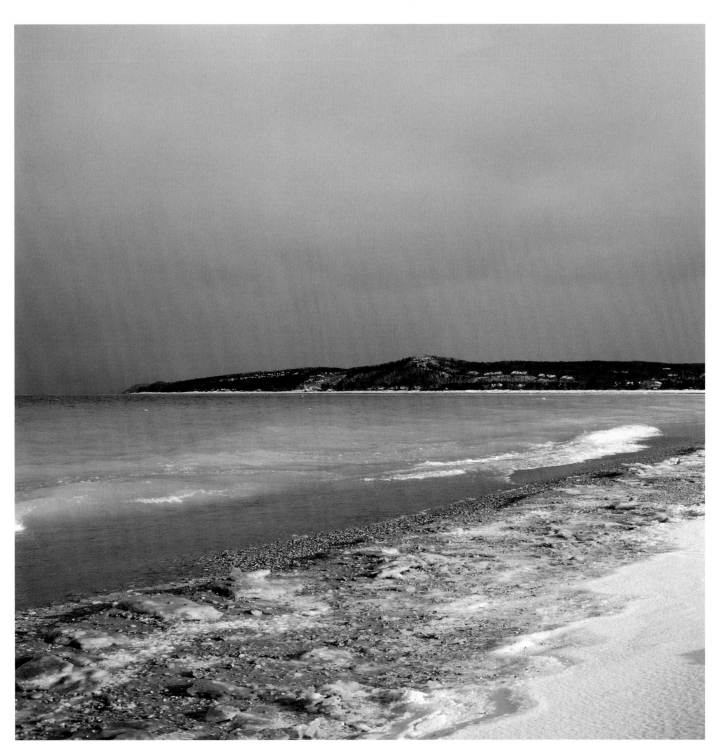

Sleeping Bear Bay looking across to the Homestead

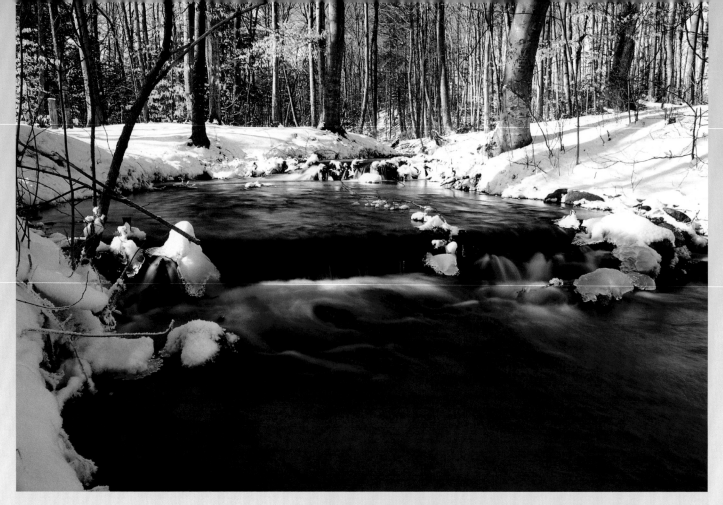

Shalda Creek in the winter

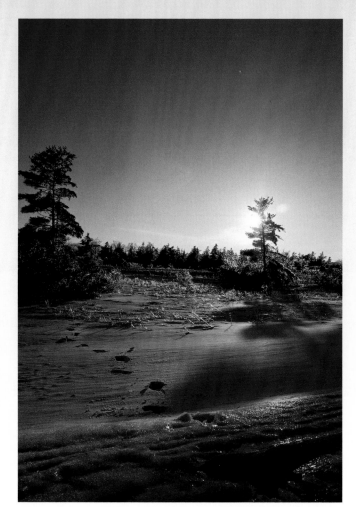

*A winter's white pine shadows
in Glen Haven*

74.

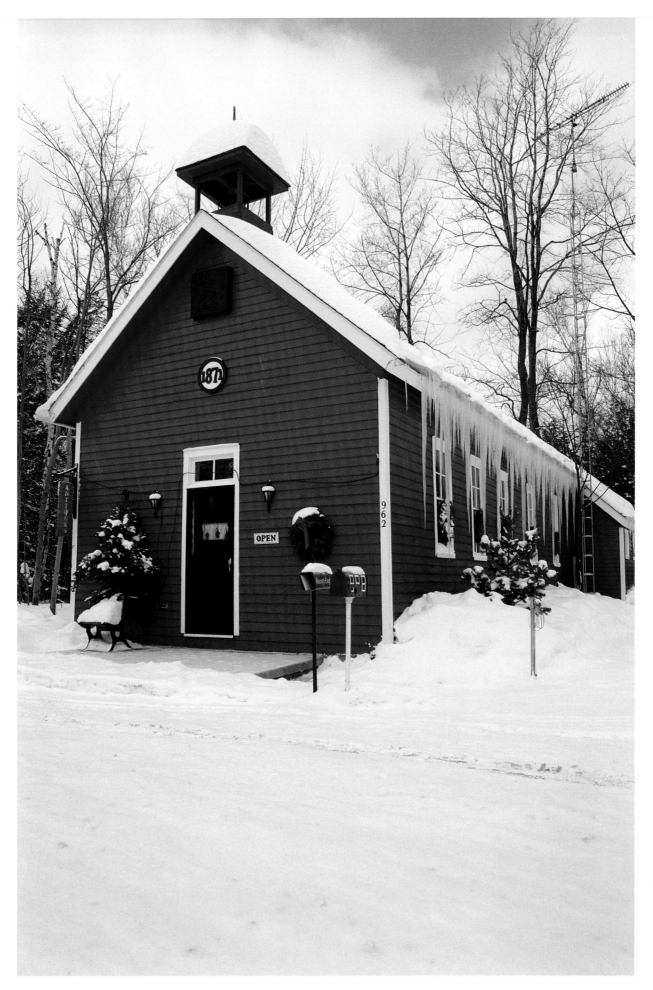

The red school on M-22 near Little Traverse Lake

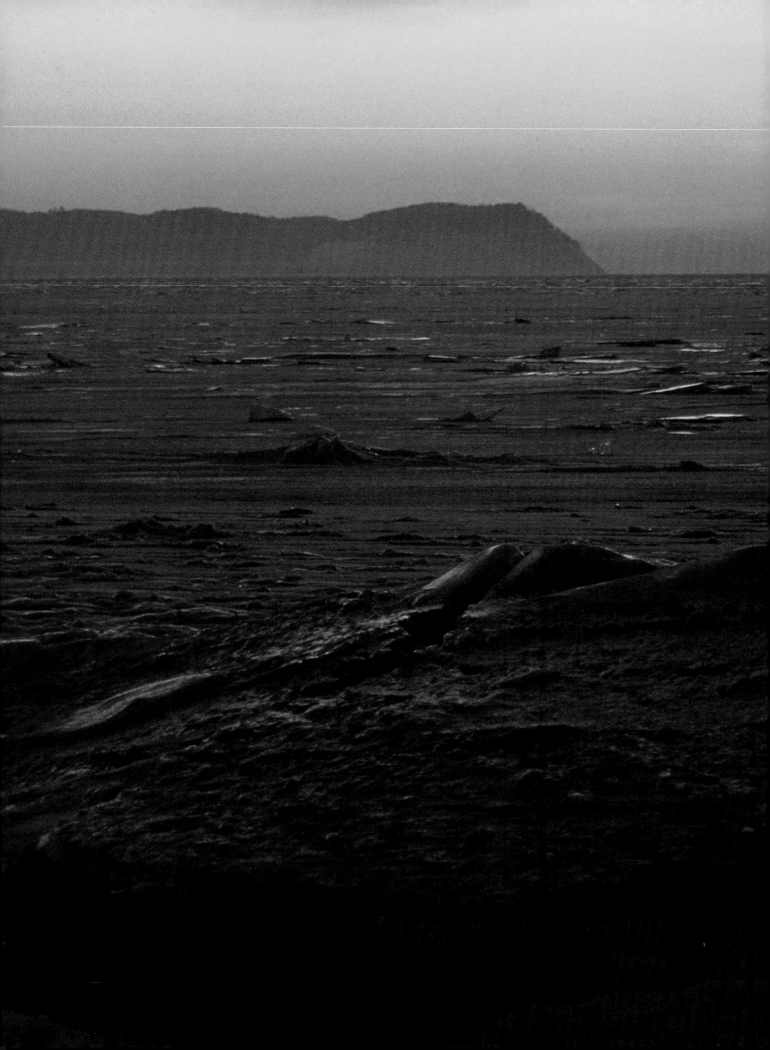

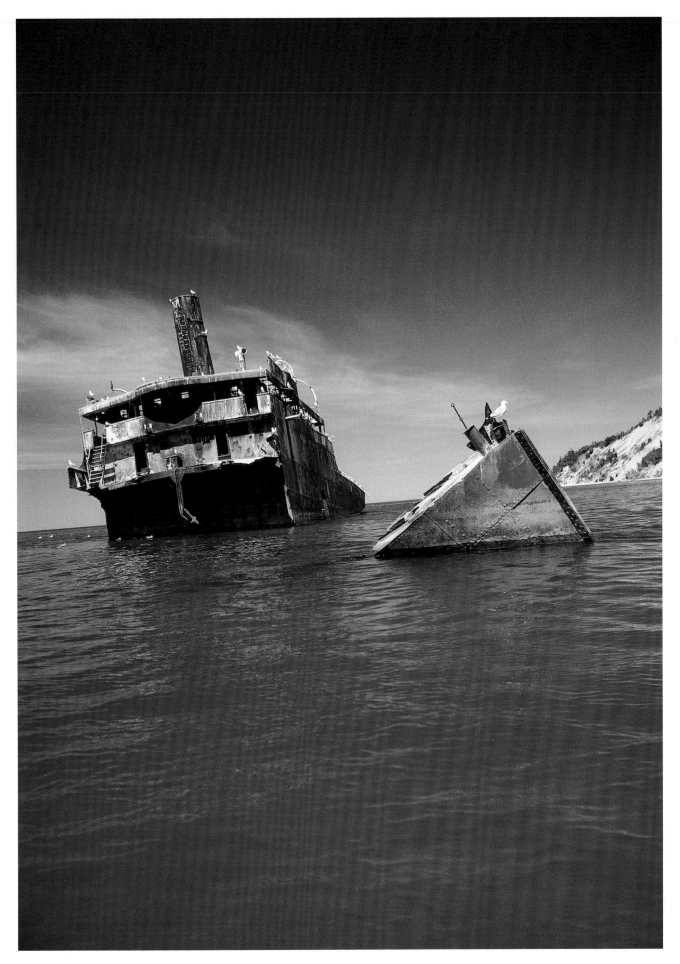

Opposite page:
Looking west to Pyramid Point

The Francisco Morizan *wreck*
off South Manitou Island

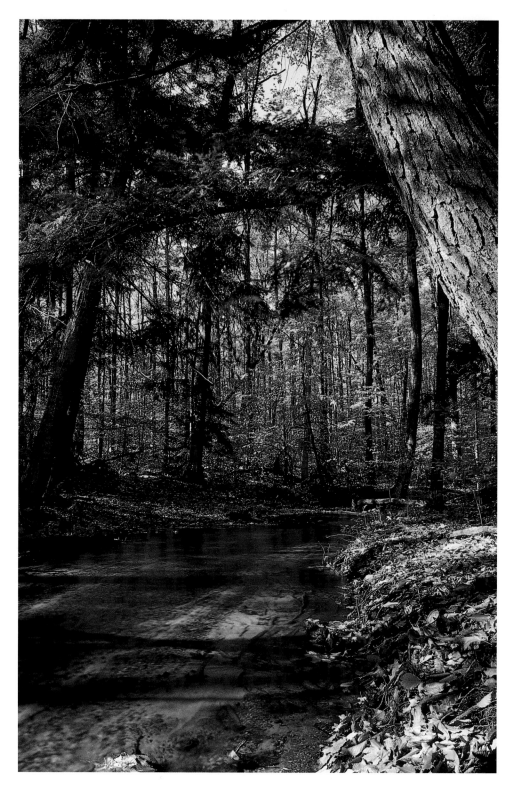

Upstream Shalda Creek

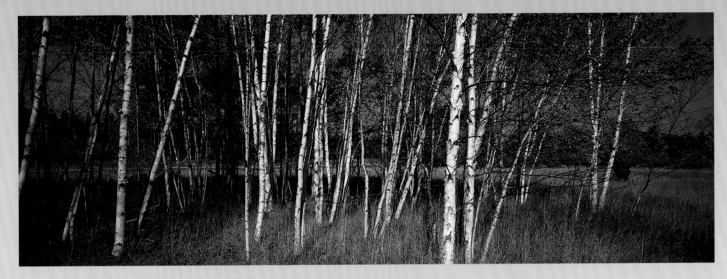

M-22 near Little Platte Lake

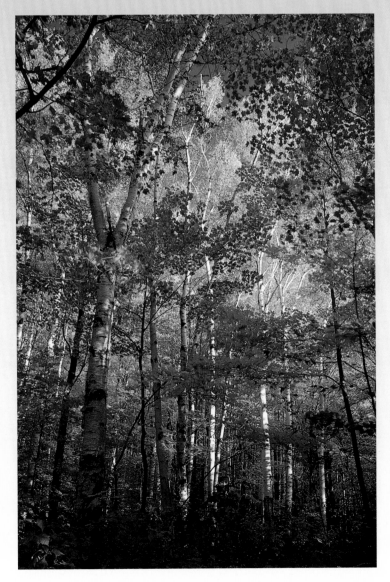

Golden birch near Loon Lake

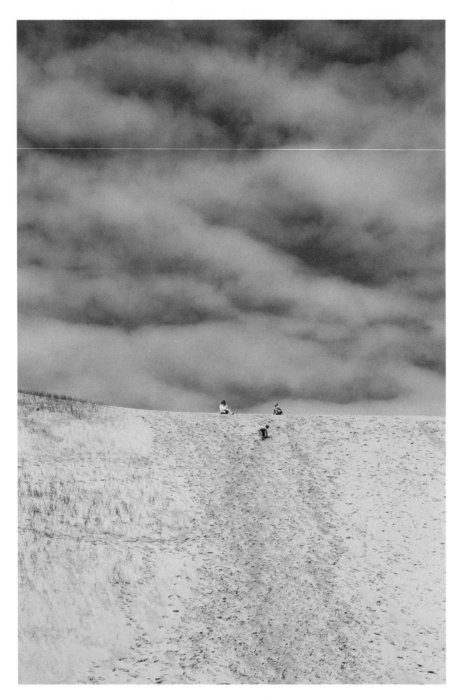

The Dune Climb

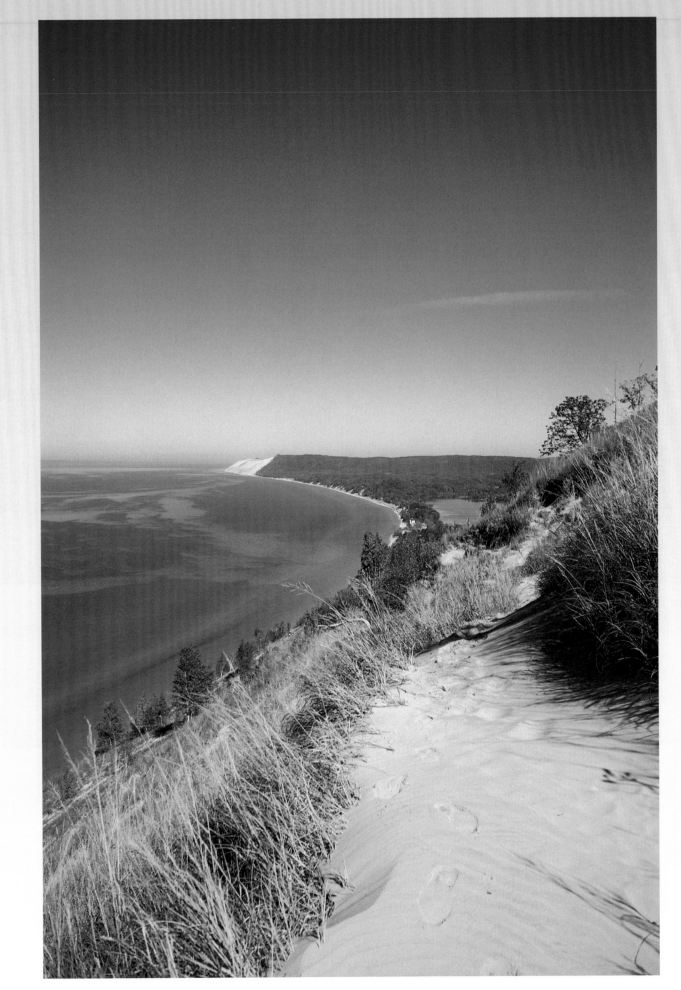

Beyond the boardwalk at Empire Bluffs

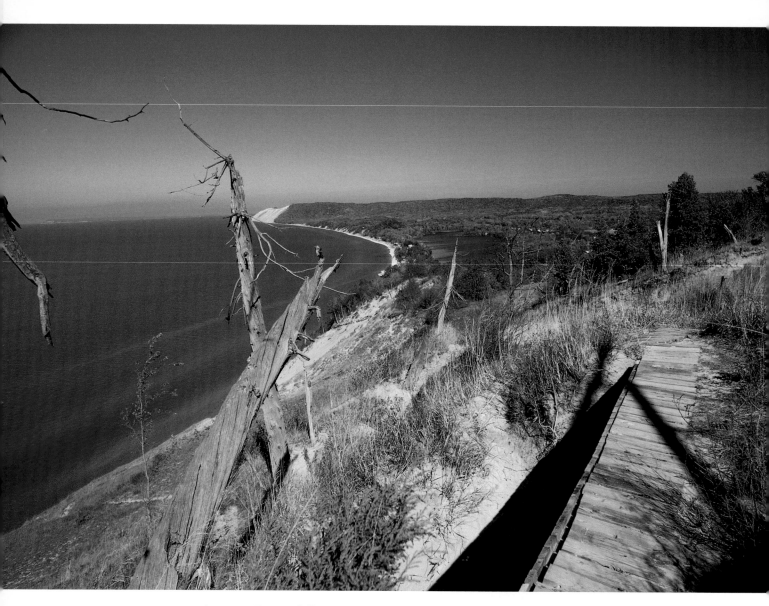

Autumn at Empire Bluffs

Another cedar taken down by the drifting sands

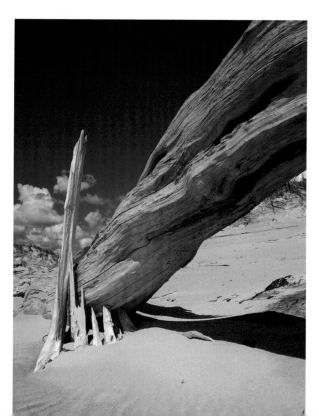

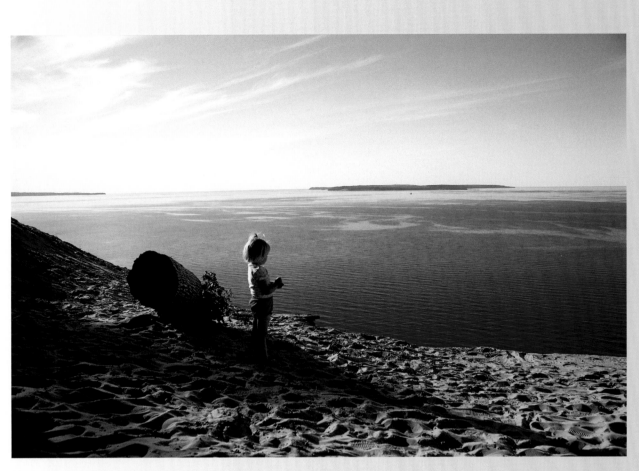

Late afternoon at Pyramid Point

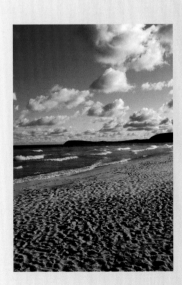

Looking north to Whaleback
from Good Harbor Beach

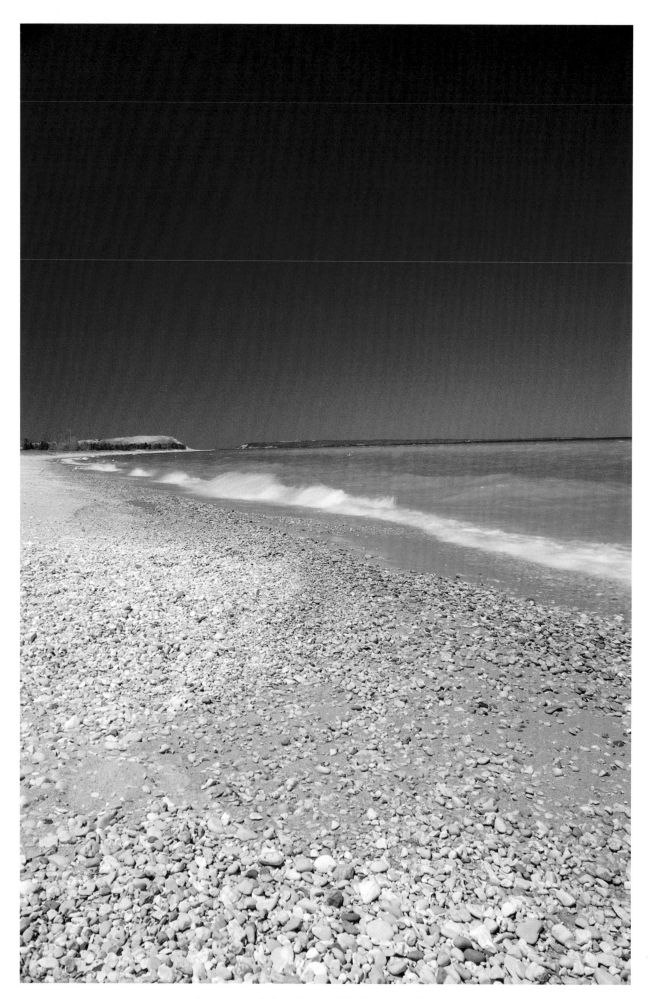

Sleeping Bear Point with South Manitou nine miles away

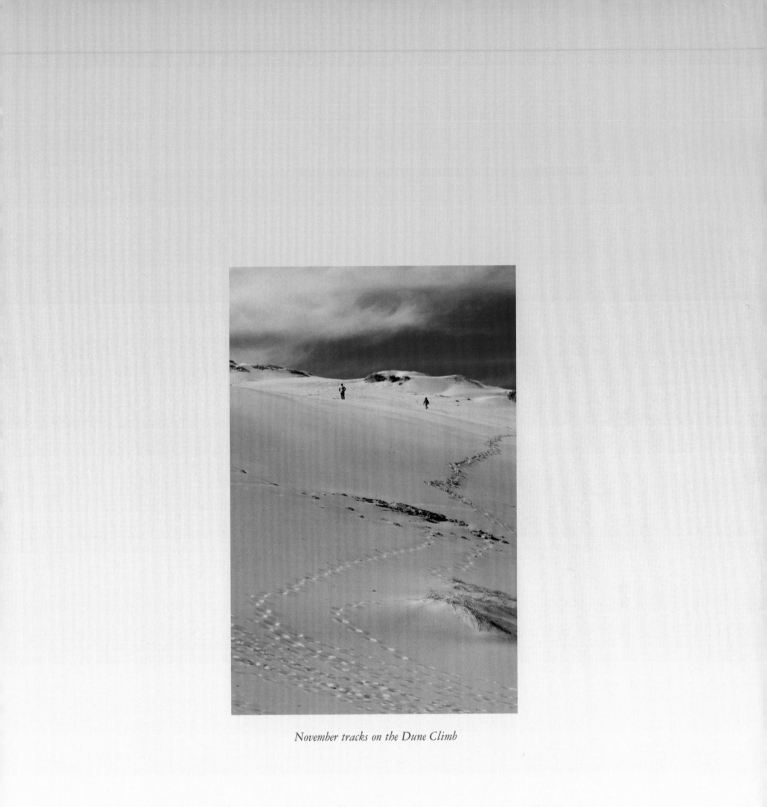

November tracks on the Dune Climb

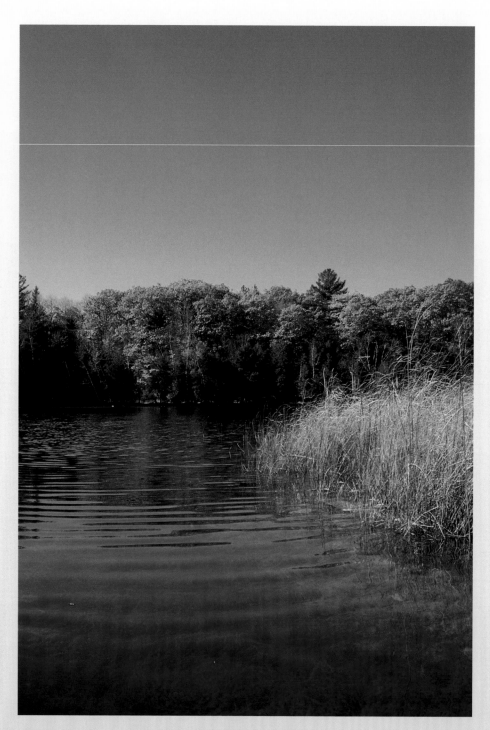

Bass Lake (near School Lake)

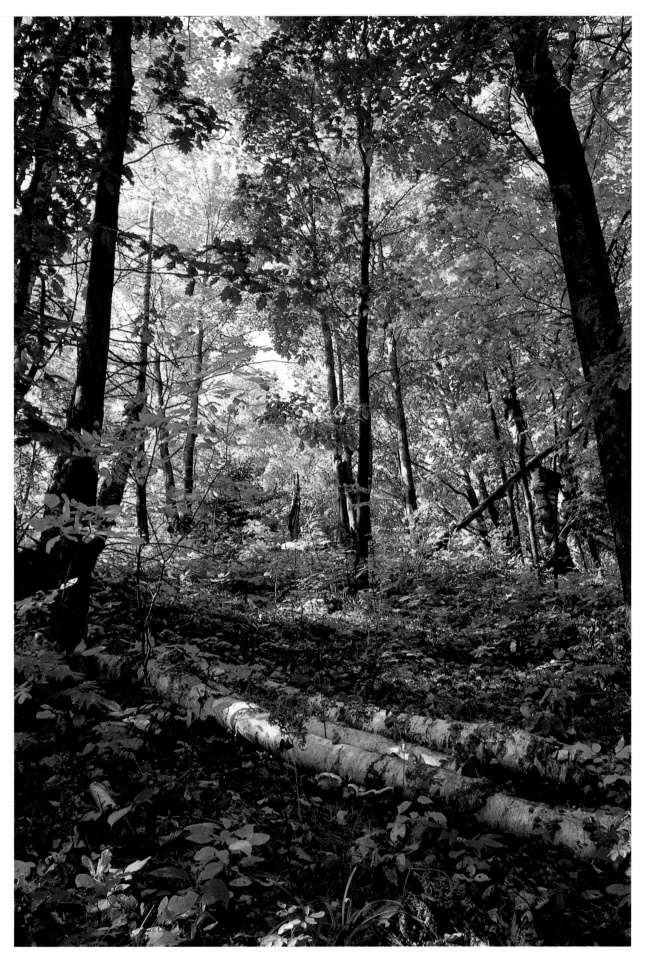

Along the Otter Creek Trail

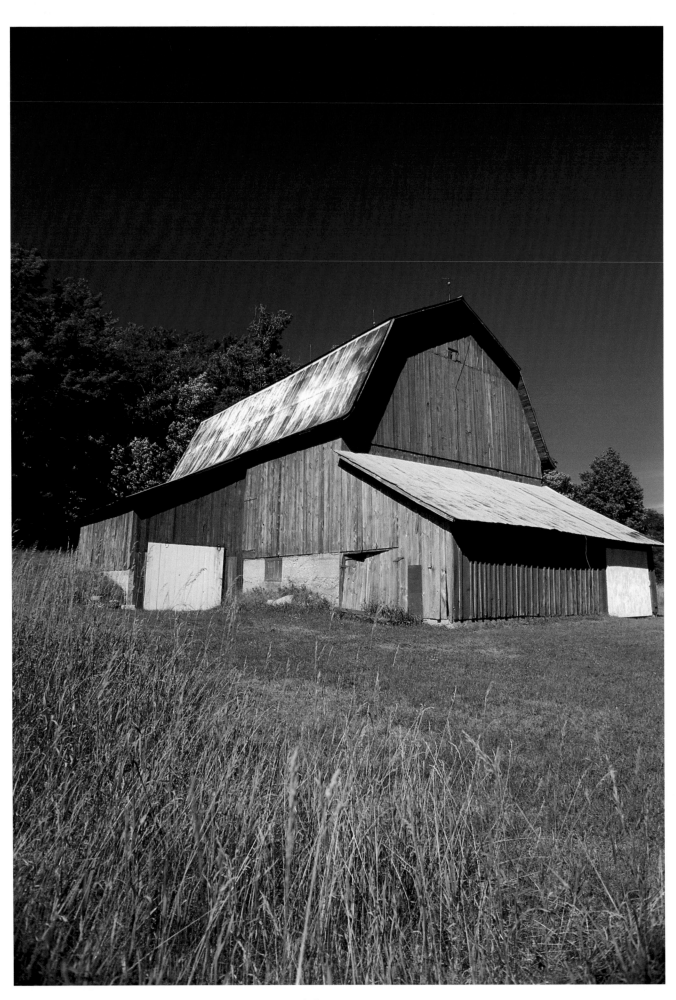

A Port Oneida barn awaiting restoration

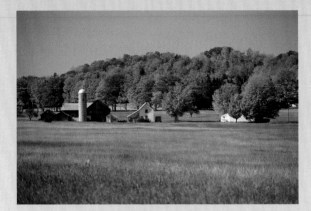

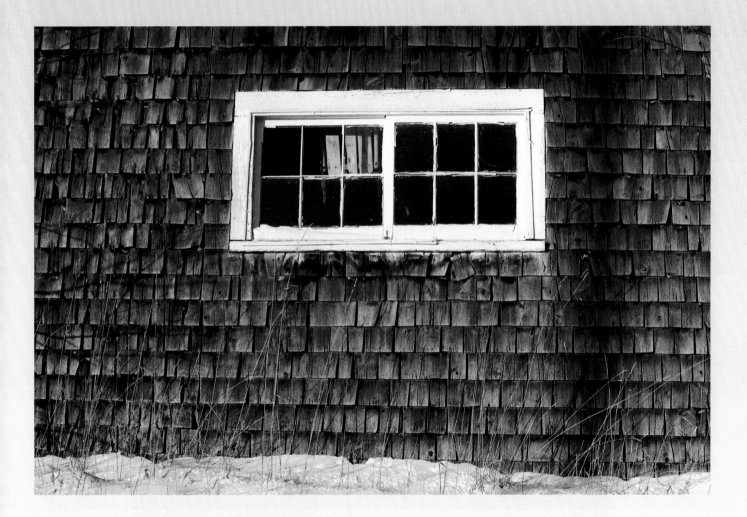

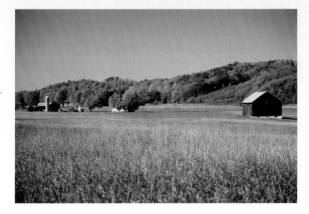

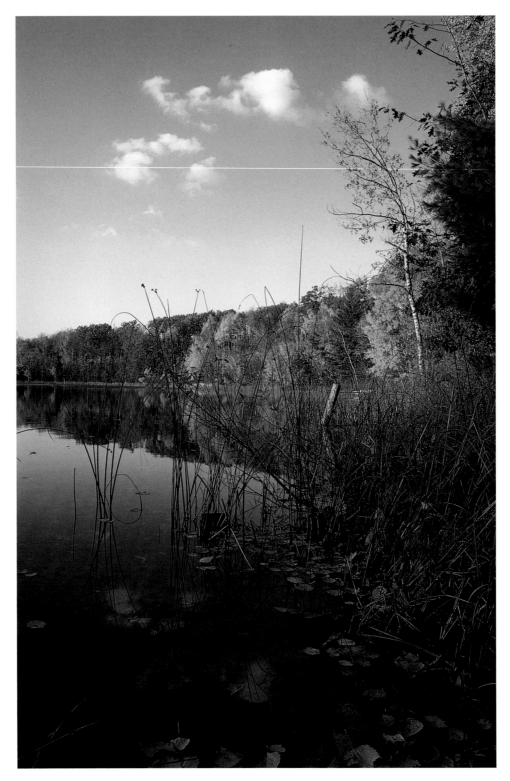

A fall of colors at Bass Lake (near Otter Lake)

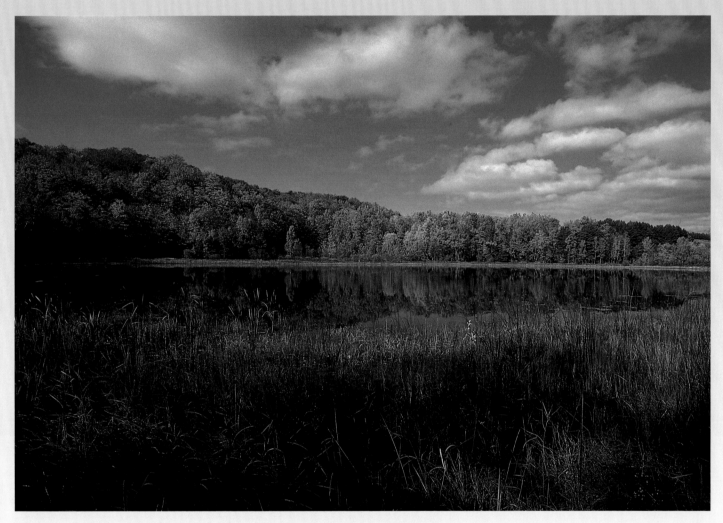

Moraine reflections in School Lake

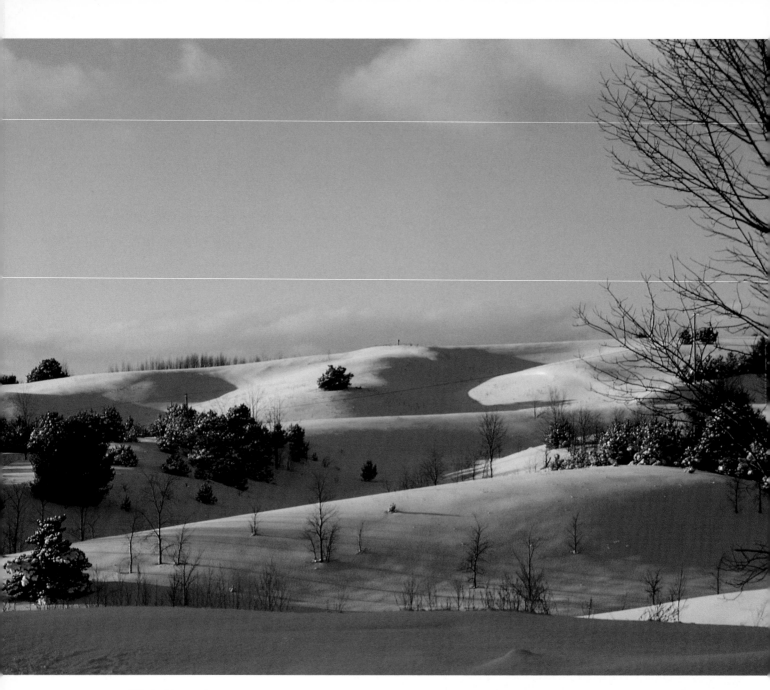

Glaciers' icy work

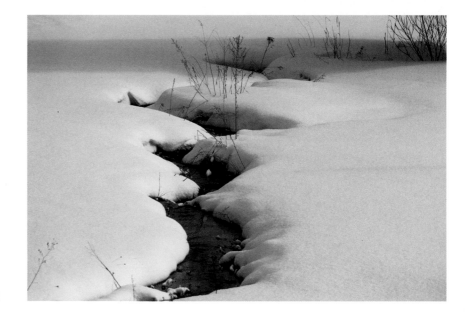

First signs of spring

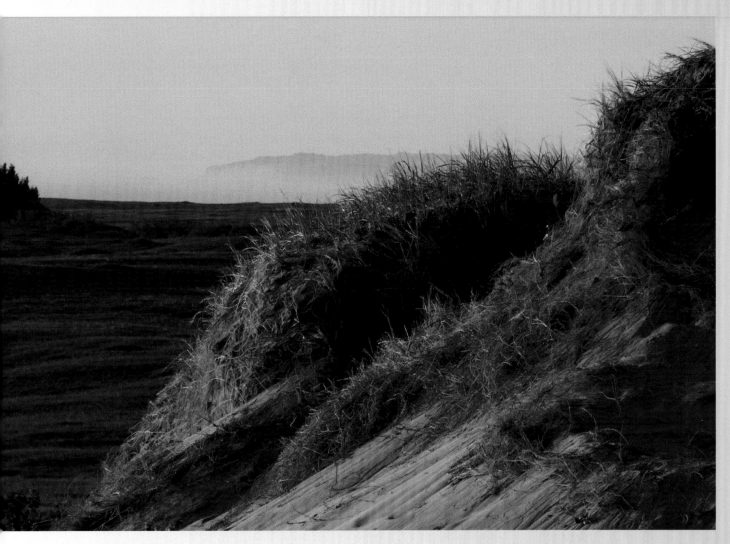

Dune grass staking its claim to the lakeshore on Pyramid Point

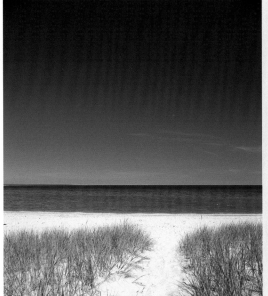

A trail to Platte Bay

Following page:
Virgin cedar in the
Valley of the Giants,
South Manitou Island

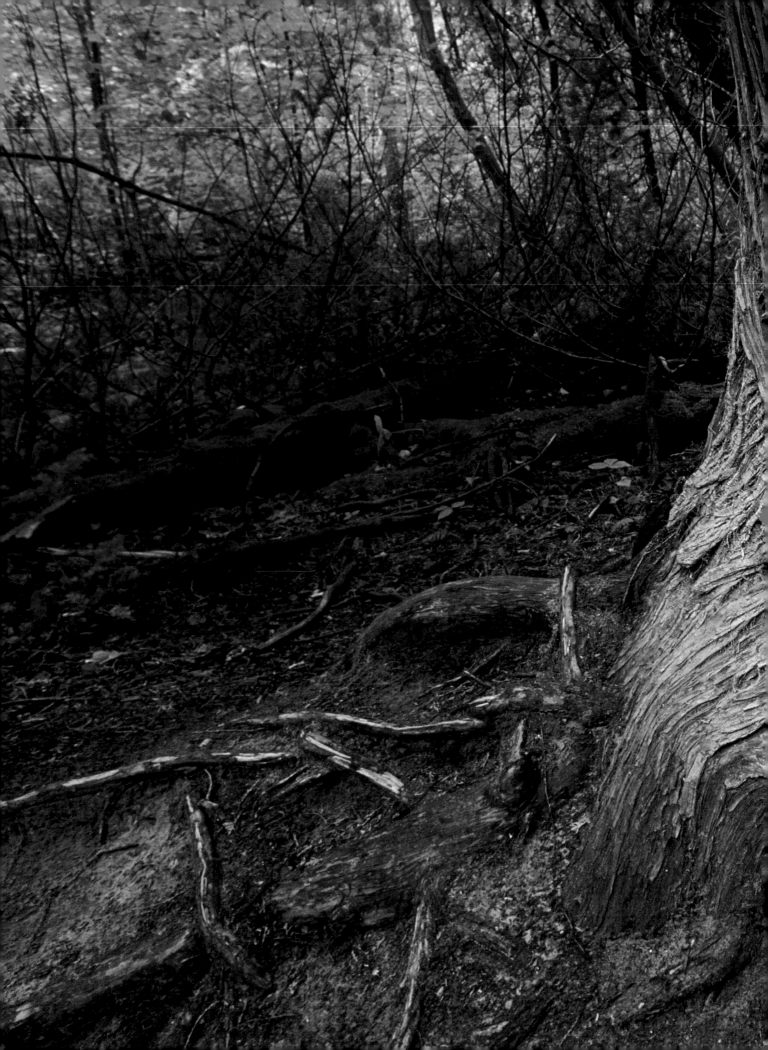

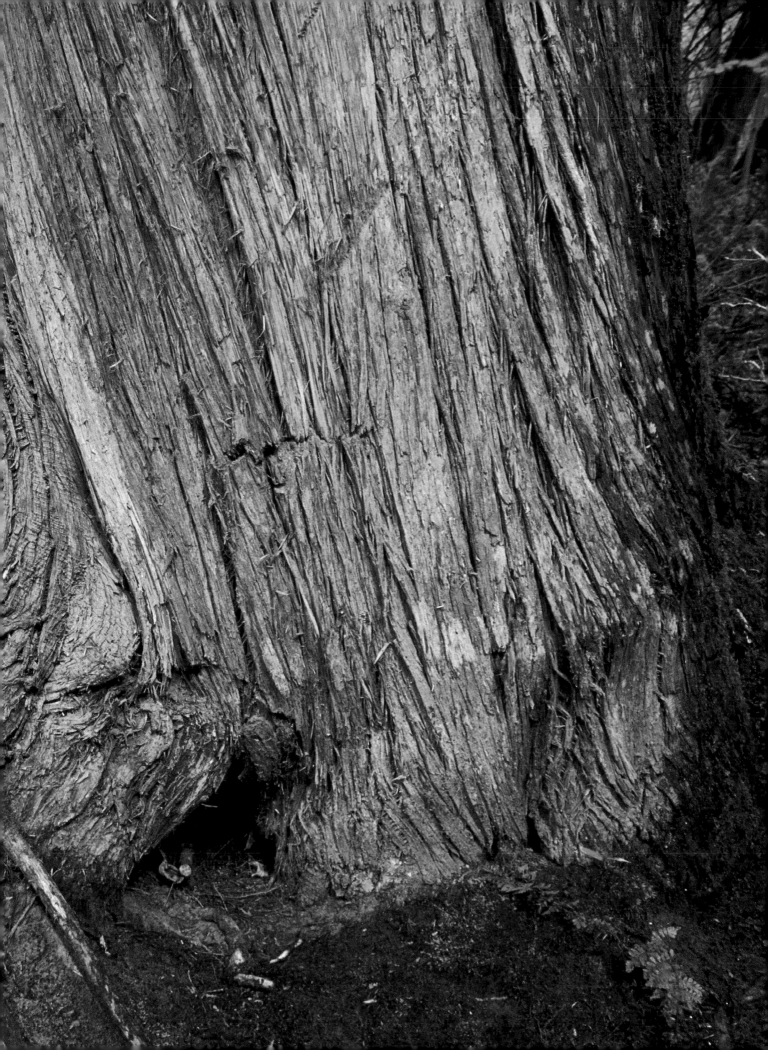

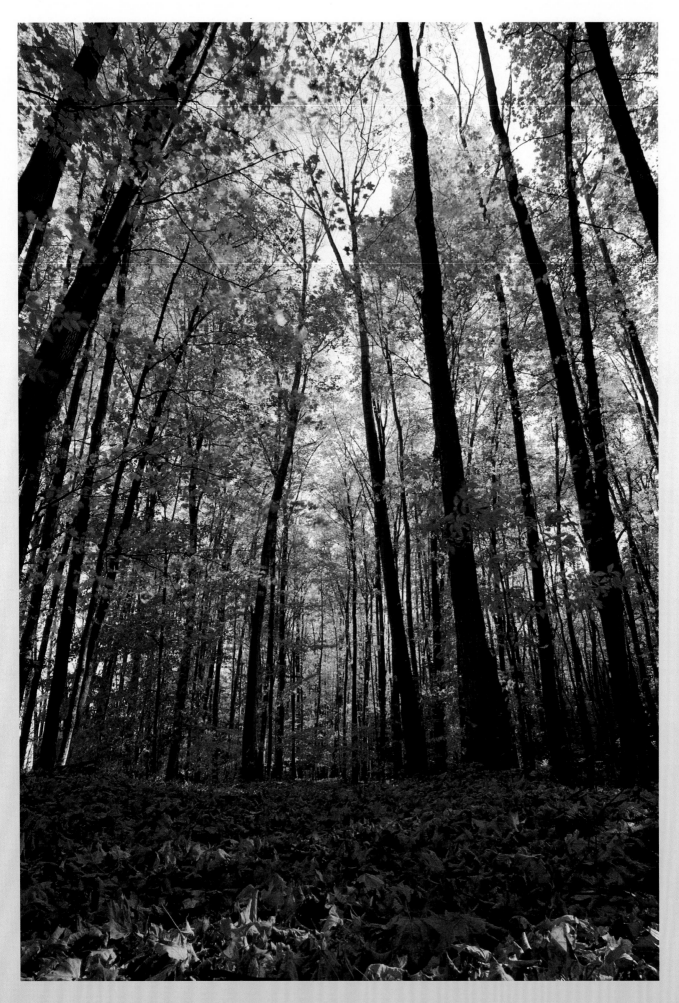

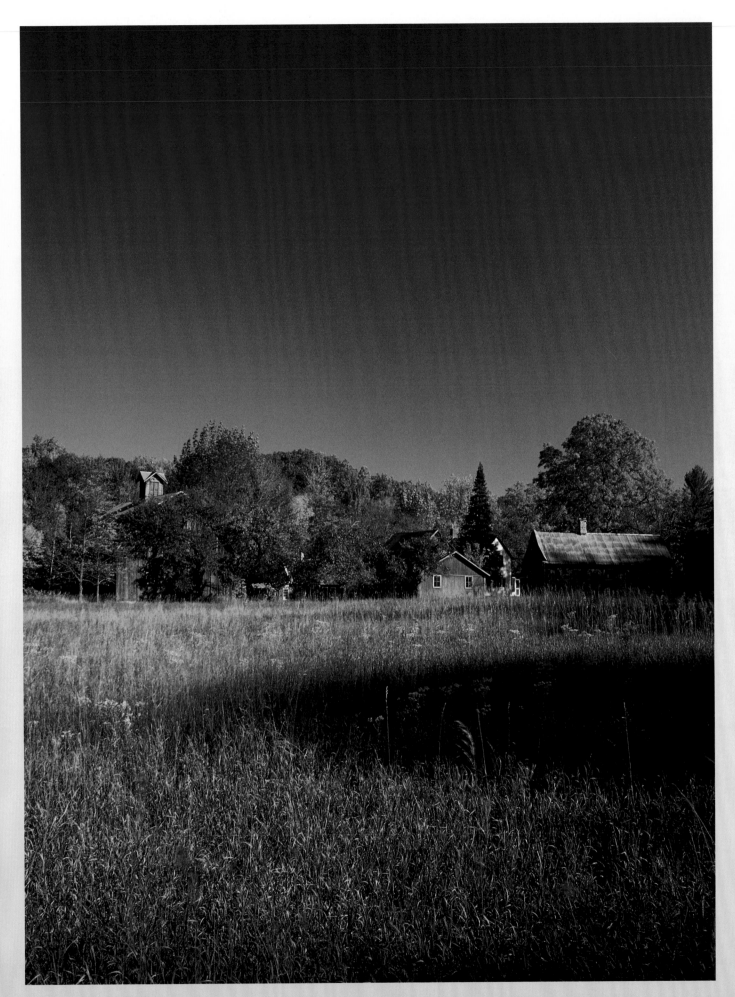

Farm along M-22

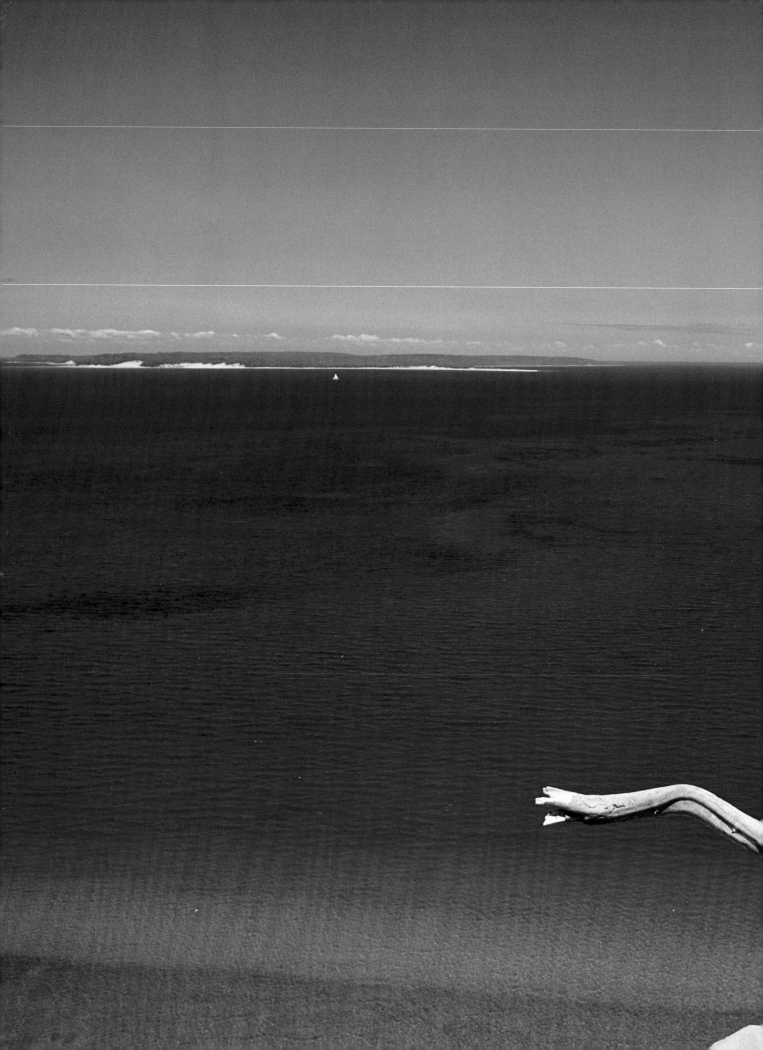

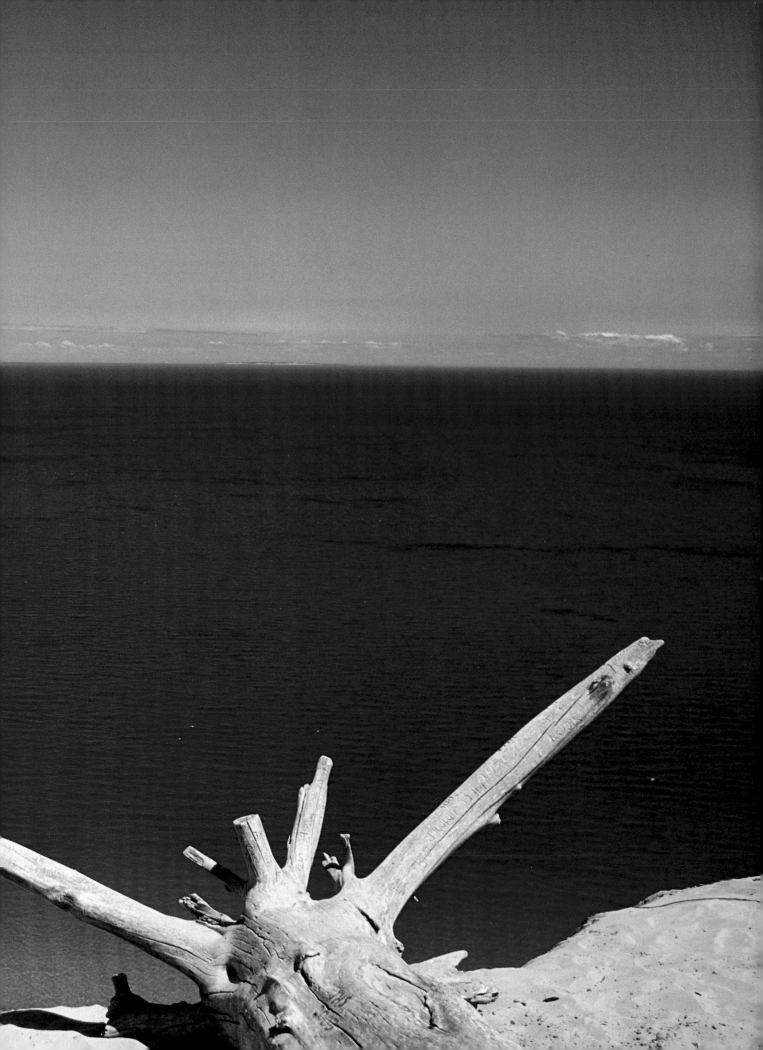

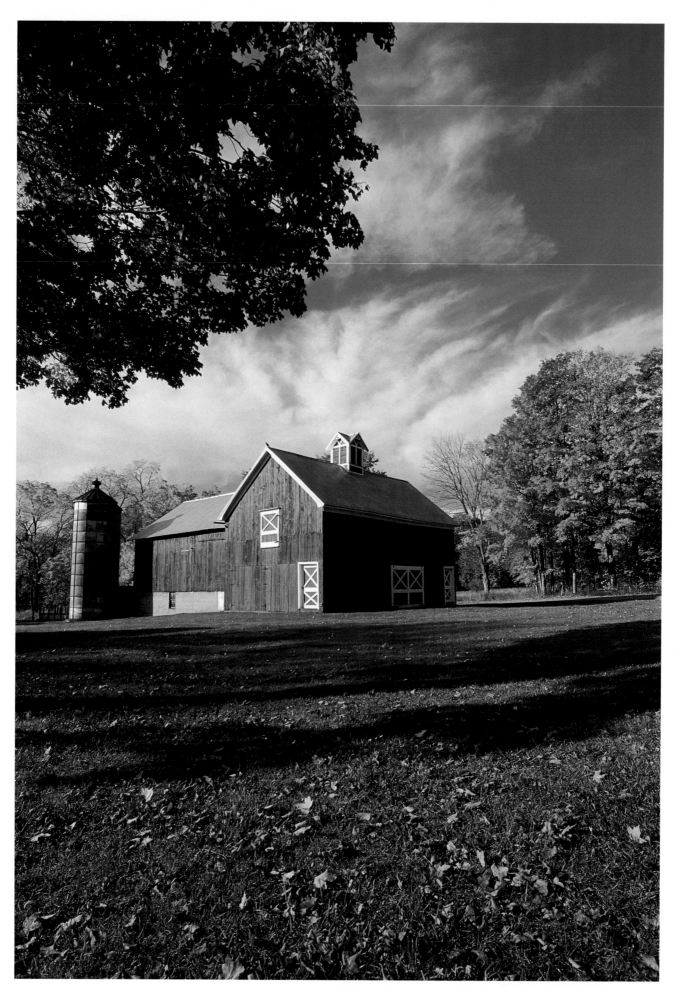

The restored barn on Stormer Road

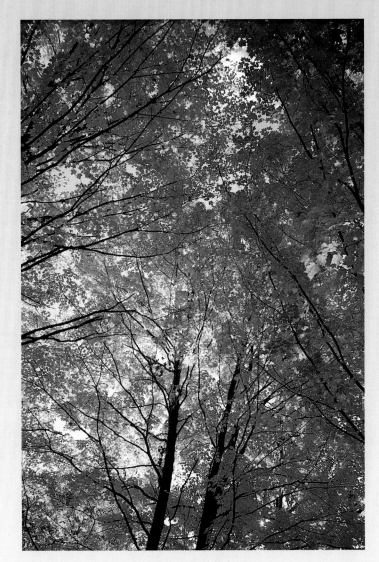

The last flames of fall

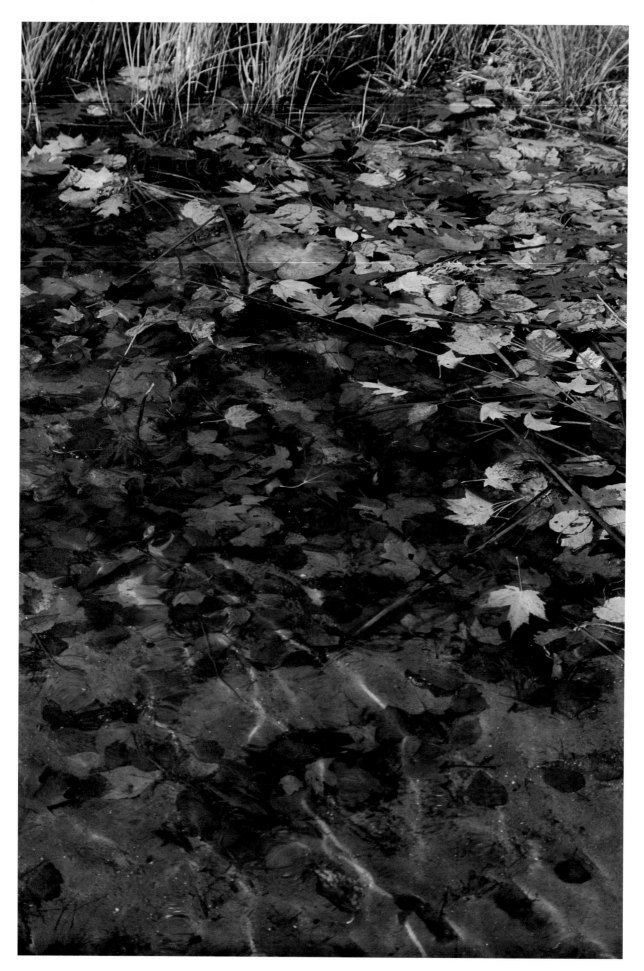

Shell Lake's Monet

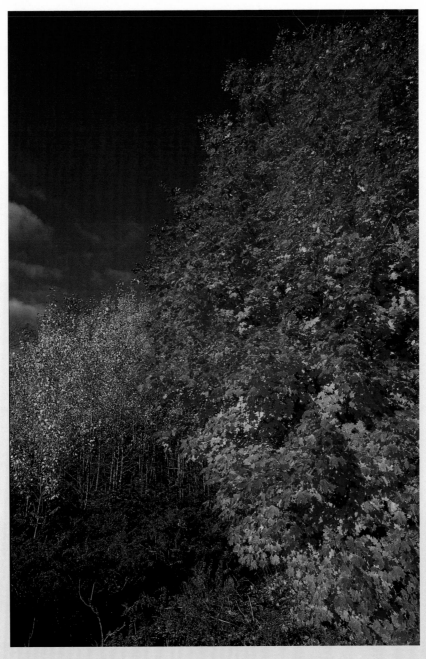

Poplar, maple and sumac combining their colors

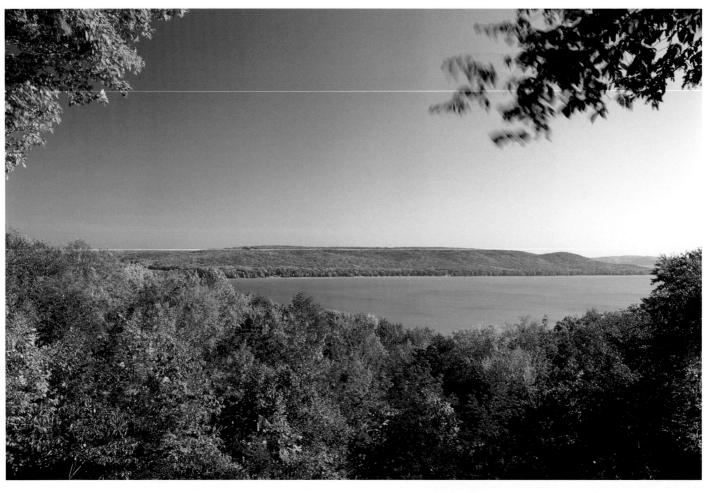

Little Glen from Pierce Stocking Drive

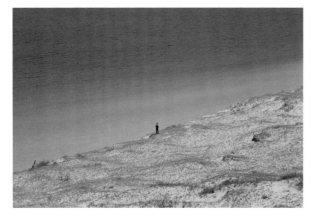

Pyramid Point escarpment

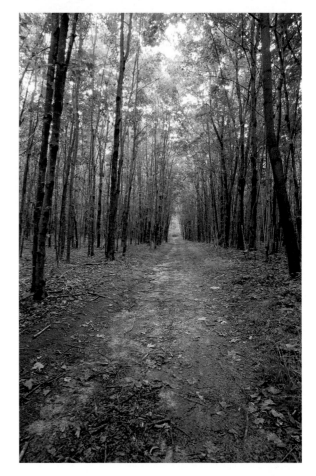

Trail to Valley of the Giants,
South Manitou Island

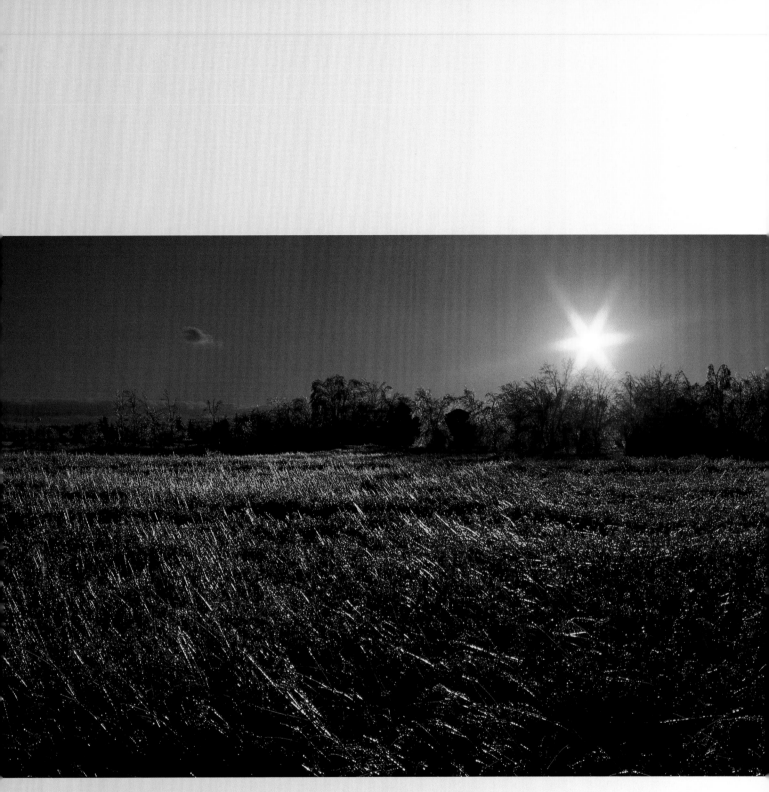

Winter's first grip

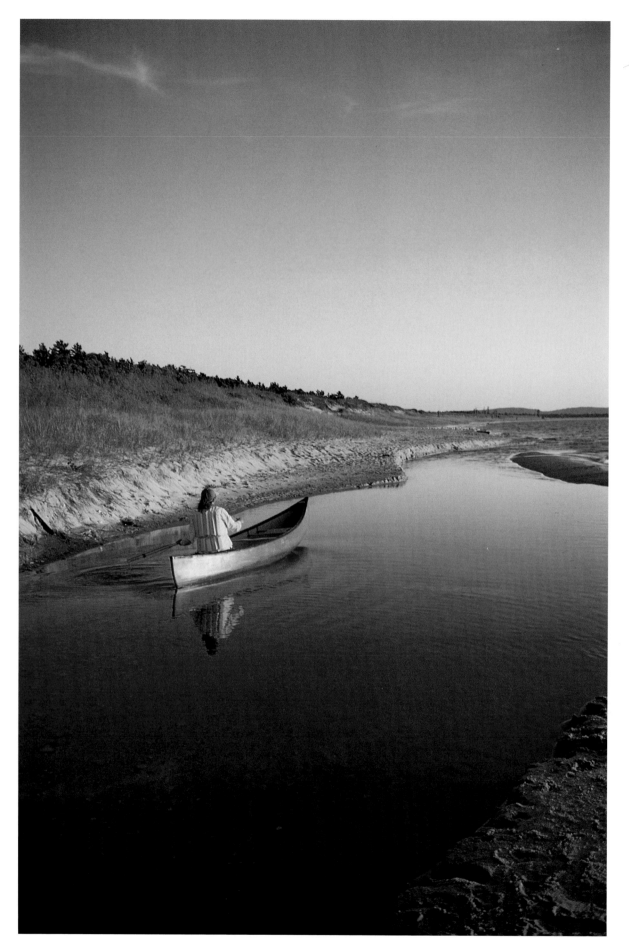

Otter Creek leading into Lake Michigan

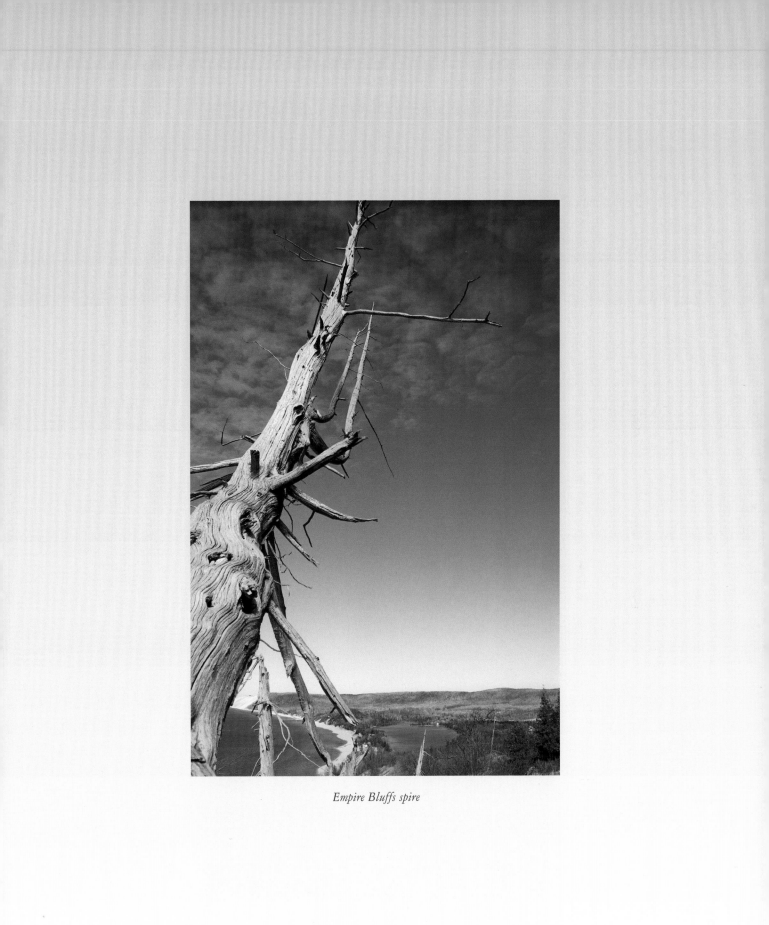

Empire Bluffs spire

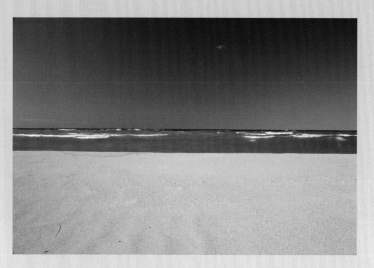

North Bar Beach

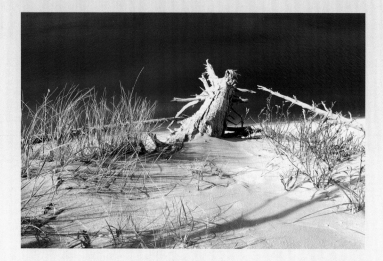

The ghost forest precipice

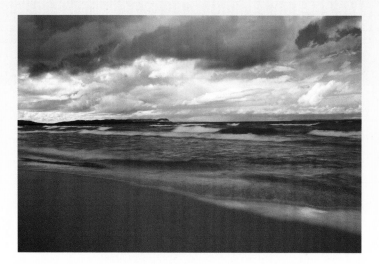

A November storm at Good Harbor Bay

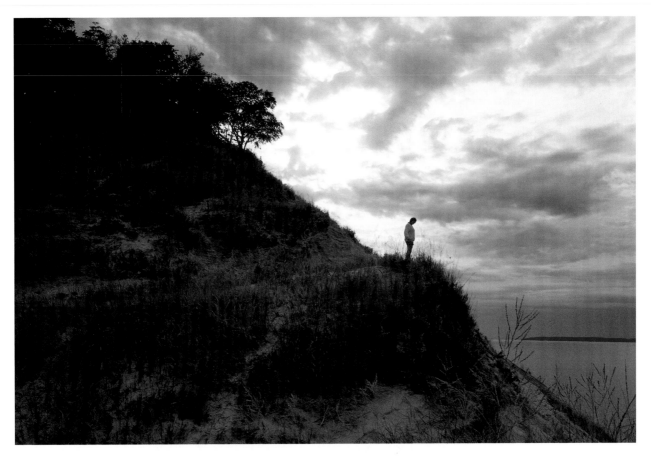

Just below, and north of Pyramid Point

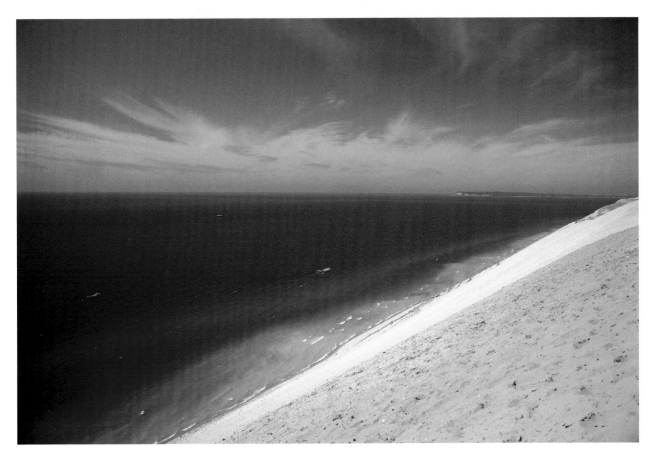

Along the ridge to Sleeping Bear Point

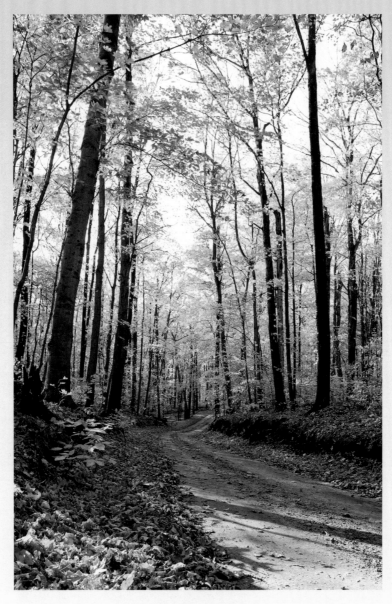

The road to Aral

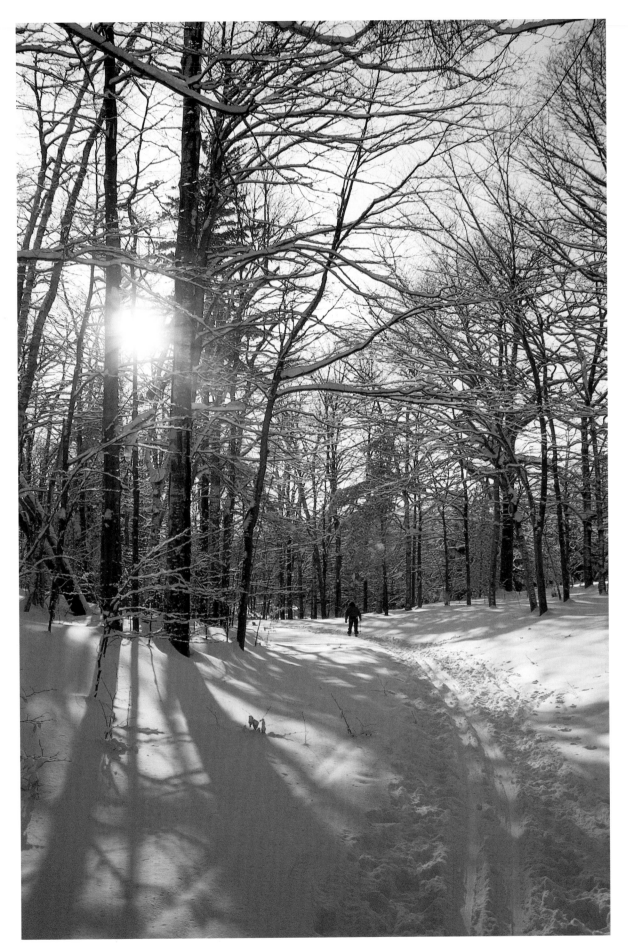

Alligator Hill ski trail

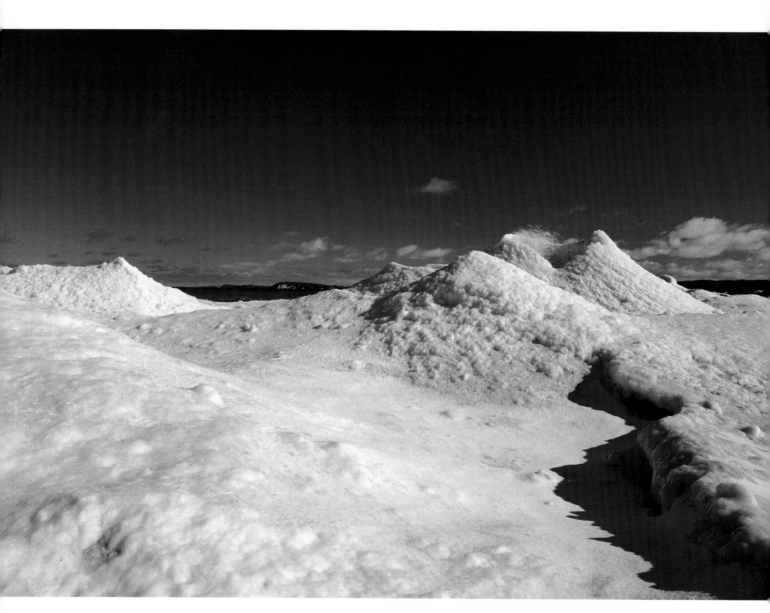

Ice craters in the lakeshore

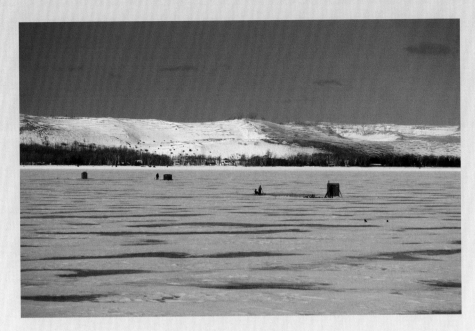

Shanties on Little Glen

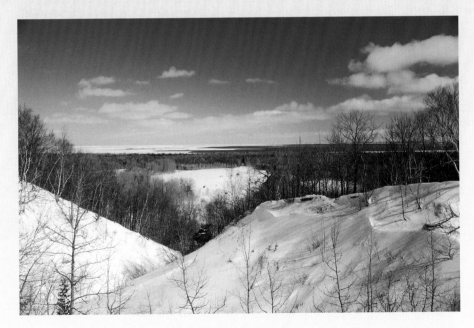

Overlook off Baker Road

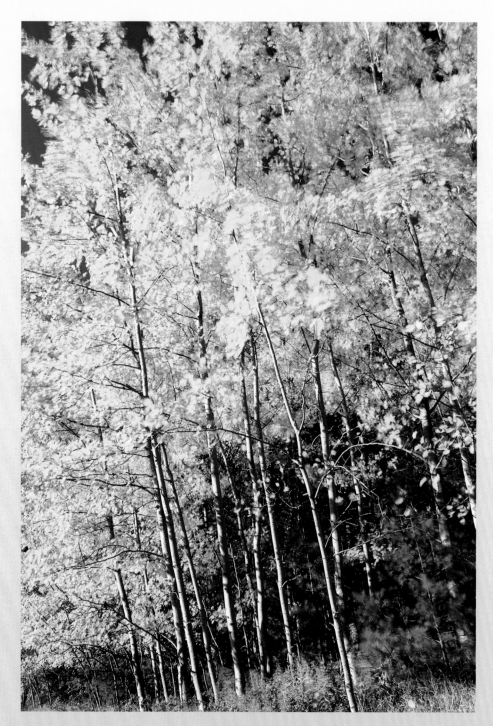

Poplars fanning their colors

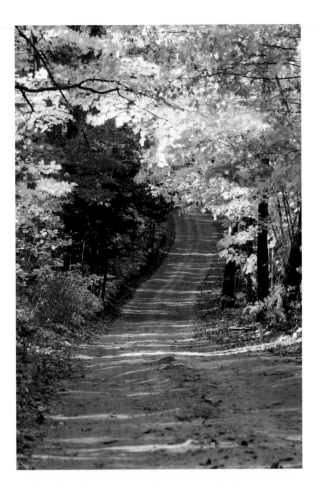

*Baker Road to
Pyramid Point trailhead*

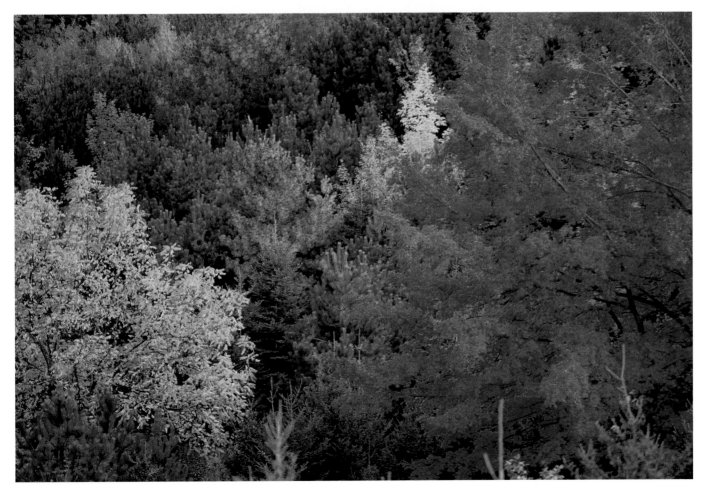

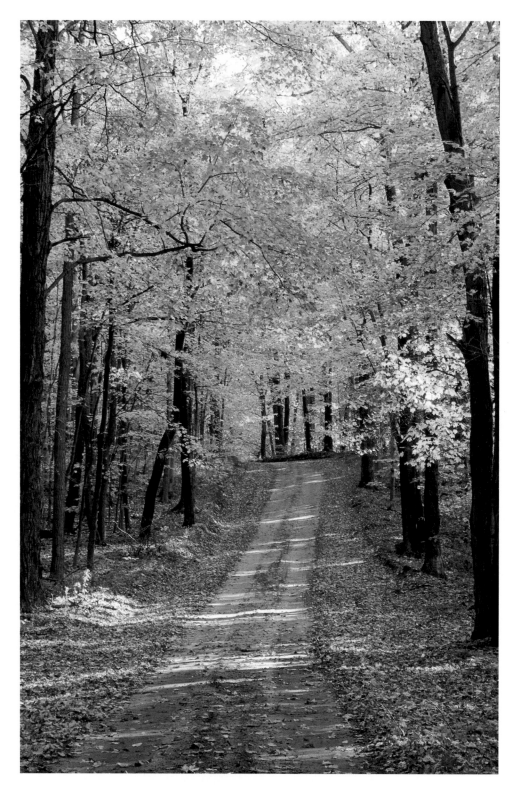

A seasonal road near Empire

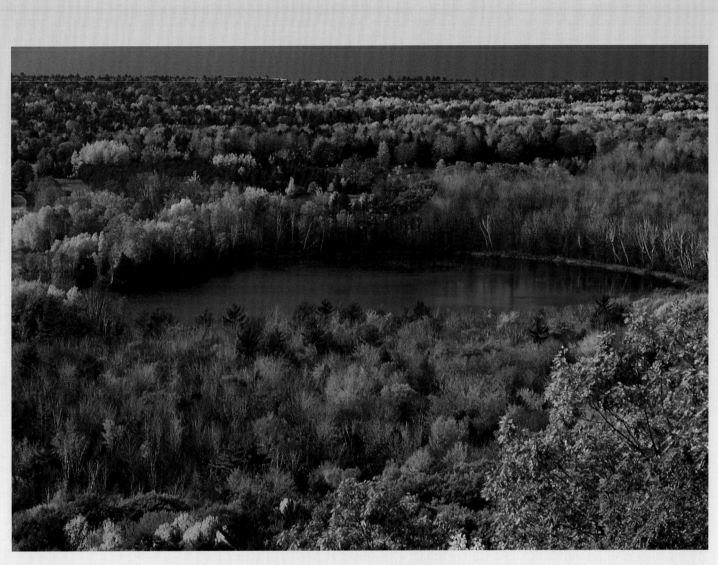

Looking down to Turtle Lake from Miller Hill

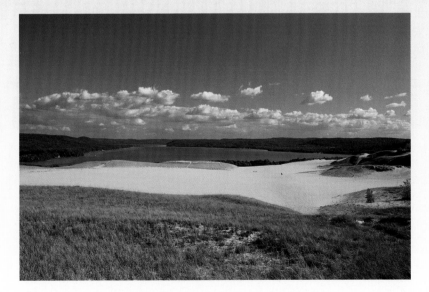

The upper Dune Climb with Little Glen Lake

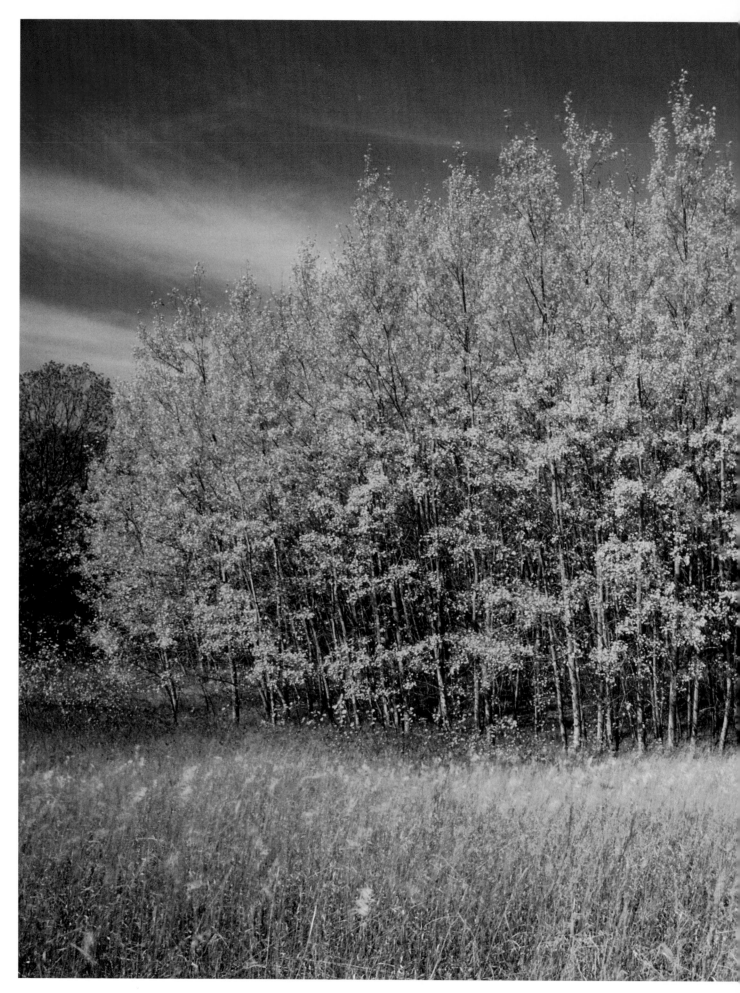

Port Oneida poplars

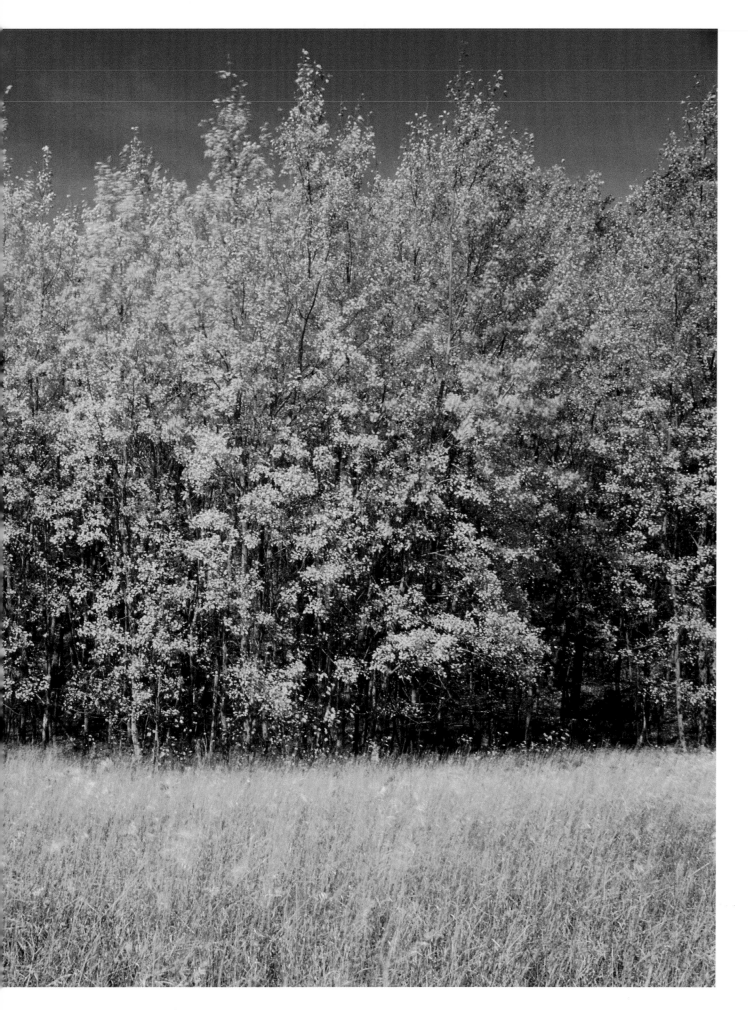

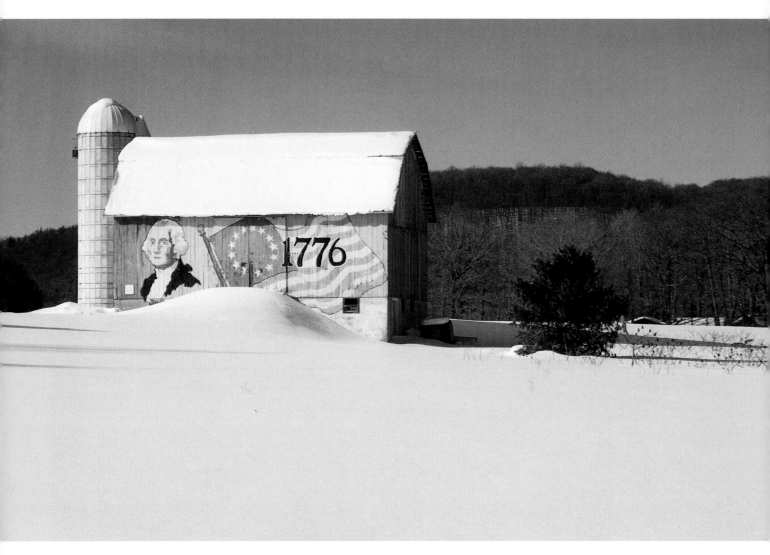

The centennial barn painted by Northport School students

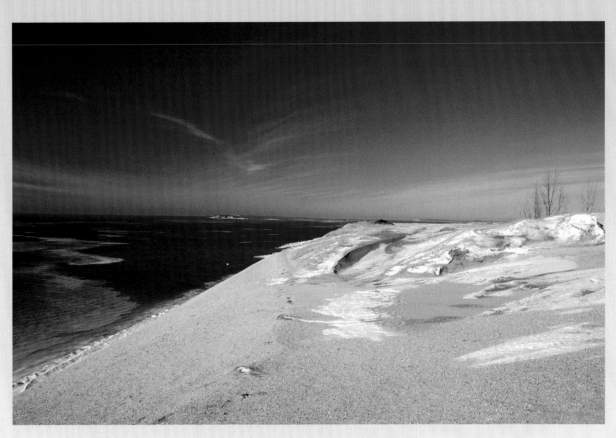

Looking north from the overlook

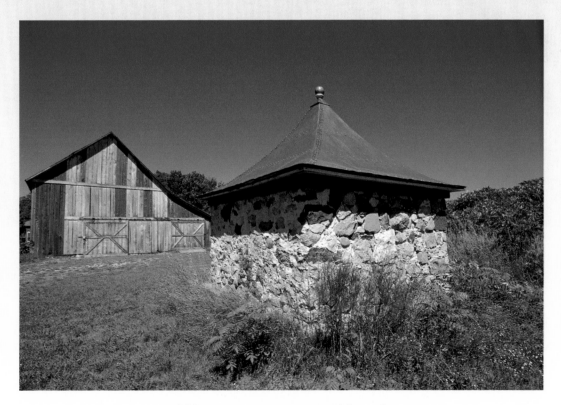

Successful barn restoration on County Road 651 and M-22

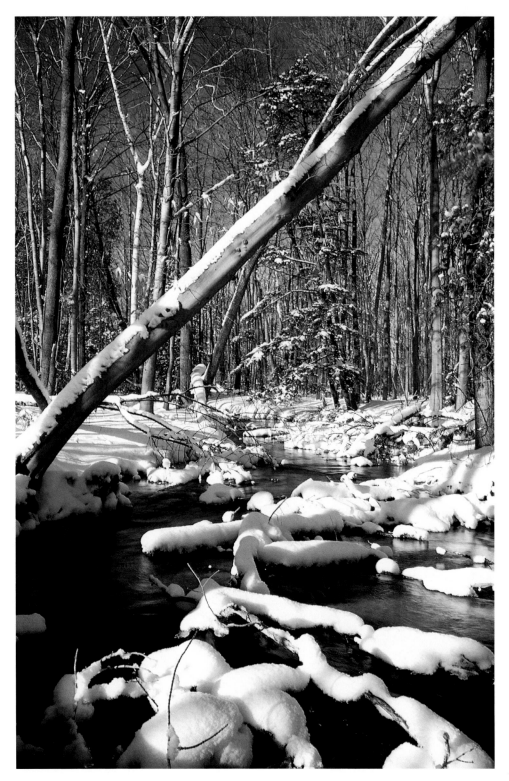

Upper Shalda Creek

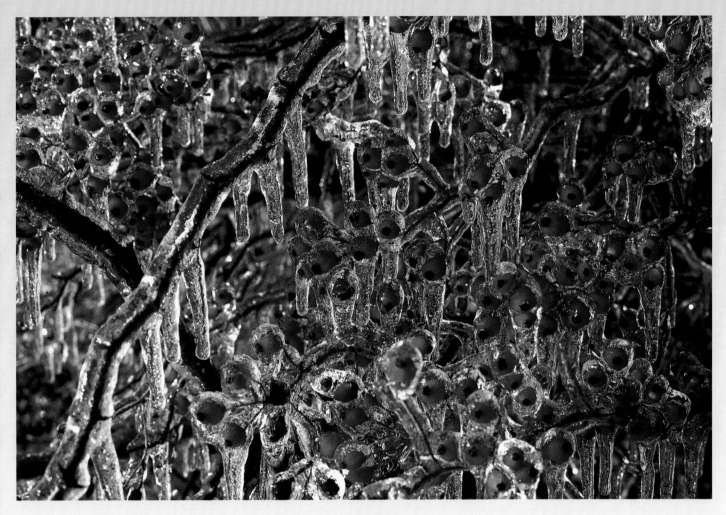

A winter surprise

Following page:
Smores on Good Harbor Bay

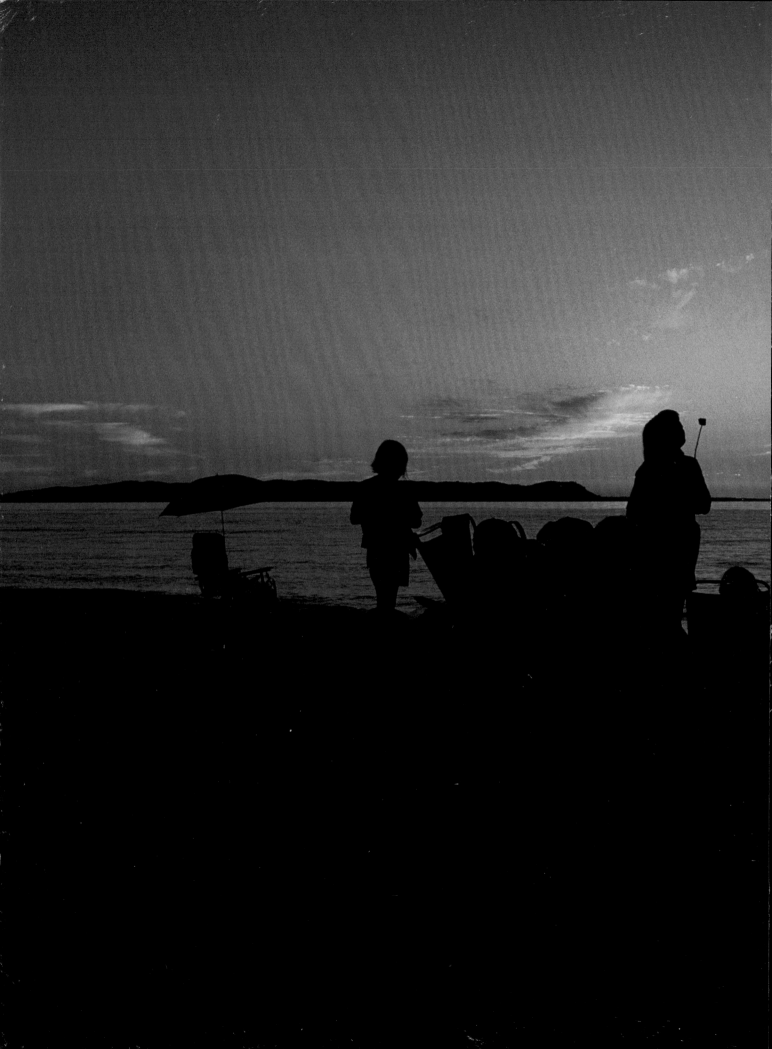

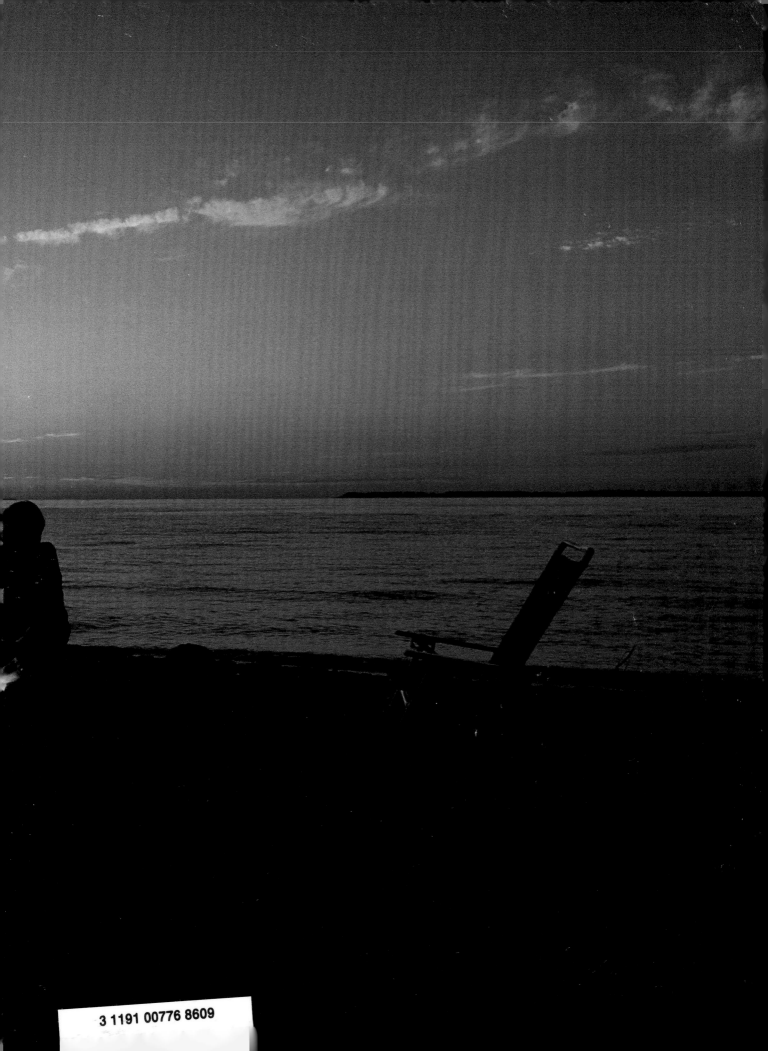